IMAGES
of America
THE RARITAN
BAYSHORE

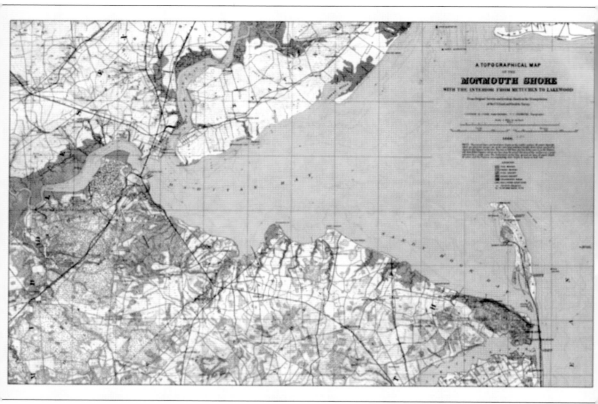

The Raritan Bay, which borders the Atlantic Ocean, New York, and New Jersey, has the shape of a triangle. It is approximately nine miles long east to west and 12 miles wide north to south. There are several waterways that flow into the Raritan Bay before it reaches the Atlantic Ocean on the eastern side. The rivers and streams bring freshwater, while the ocean carries in the salt water. (Author's collection.)

ON THE COVER: The Village Inn once stood in the Middletown Village section of Middletown Township. The inn was a popular destination for summer visitors during the early 20th century. Middletown Village is one of the oldest permanent English settlements in New Jersey, with numerous buildings dating back to the 18th and 19th centuries. This part of the township serves as the nucleus of the community in contemporary times. (Monmouth County Historical Association.)

IMAGES
of America

THE RARITAN
BAYSHORE

John Allan Savolaine and Matthew H. Ward
Foreword by John Schneider

ARCADIA
PUBLISHING

Copyright © 2022 by John Allan Savolaine and Matthew H. Ward
ISBN 978-1-4671-0915-4

Published by Arcadia Publishing
Charleston, South Carolina

Printed in the United States of America

Library of Congress Control Number: 2022944005

For all general information, please contact Arcadia Publishing:
Telephone 843-853-2070
Fax 843-853-0044
E-mail sales@arcadiapublishing.com
For customer service and orders:
Toll-Free 1-888-313-2665

Visit us on the Internet at www.arcadiapublishing.com

*To my wife, Cathy, my son, Clark, and my
two grandsons, Grant and Lee.*

—Al

This book is dedicated to my Ward girls.

—Matt

CONTENTS

FOREWORD

My love of Raritan Bay has become so much deeper and richer after reading this book, which was written by my dear friends John Allan Savolaine and Matthew H. Ward. They have provided all of us with a wonderful collection of people, events, photographs, and stories that were part of the rich history of this area.

Thank goodness for books like these that allow us to go back in time and get a sense of what life must have been like for our predecessors. Every page and every picture tells the story of our past. The images selected by the authors are truly unique and significant representations of everyday life. I'm certain you will be amazed by the collection.

This is the type of book that can be enjoyed more than just once. It's something to be treasured and shared with others. In fact, I'm anxious to look through it again to discover something I may have missed.

—John Schneider

Author John Schneider is the host of a weekly television program called *Jersey Bayshore Country*, which has more than half a million viewers. His published books include *A Historical Journey Across Raritan Bay*, Past & Present: *Sandy Hook*, and *Highlands: A Love Story*.

ACKNOWLEDGMENTS

With an image-driven book that covers the numerous communities that make up the Raritan Bayshore region, we would not have been able to complete this project without the support of several historians, librarians, archivists, and photographers. Cathy Savolaine, John Schneider, Kim Bedetti (Monmouth County Historical Association), Randall Gabrielan (Middletown Township Historical Society), Kristen Hohn (Monmouth County Park System), and John DiSanto were key players in ensuring the successful completion of this project.

The Corcione family (Sean and Erica), Peter Lloyd, Assemblymen Gerry Scharfenberger and Rob Clifton, Tom Valenti (Middletown Township Historical Society), Raven Rentas (Township of Middletown), Tara Berson (Township of Middletown), Mayor Tony Perry (Township of Middletown), Jeremy Hawkes (Arizona State University Athletics), Lindsey Olsen (Southern Methodist University Athletics), Jeff Ranu, Rhonda Beck-Edwards (Holmdel Historical Society), Art Rittenhouse (Sayreville Historical Society), Tony Vecchio (Keyport Fire Museum), Holly Hughes (Historical Society of South Amboy), Henry Hascup (New Jersey Boxing Hall of Fame), Art Boden (Keansburg Historical Society), Mark Chidichimo (Matawan Historical Society), Lisa Stein (Woman's Club of Matawan), Glenn Pike, Scott Mazzella, Brian Casse, Carton Brewing, Atlantic Highlands Historical Society, Gordon Bond, Keyport Historical Society, Herschel Chomsky (Perth Amboy Free Library), Richard Pucciarelli (Madison–Old Bridge Township Historical Society), Dr. Richard Labbe (Sayreville Board of Education), Nick Solari (Quinnipiac University), and American Legion Matawan Post 176 (Anthony Mapp, Robert Montfort, and Robert Meyer) were also very helpful in providing feedback, support, photographs, and information to this project.

We would also like to thank Amy Jarvis, Katelyn Jenkins, and Angel Prohaska from Arcadia Publishing for their support, feedback, and patience as we worked through this project. Matt would like to thank his Caracciolo grandparents (John and Mildred), uncle Johnny Caracciolo, and Ward family members for instilling in him a sense of pride in where he comes from. Finally, we would like to acknowledge former professional boxer John Molnar and noted Civil War historian Tom Burke. Both men passed away during the drafting of this book and are sorely missed by all who knew them.

INTRODUCTION

The Raritan Bayshore region of central New Jersey is an area that encompasses communities in Monmouth and Middlesex Counties. The northernmost part of the Jersey Shore, the region is rich in history, nature, and recreation.

When one thinks of the Raritan Bayshore region, there are several thoughts that may come to mind. You may envision the exciting New York metropolitan area with all of its outstanding sites and attractions. You may think of our great national leader George Washington and his critical movements at the beginnings of the American Revolution in this location. Then you might feel the sand on your toes and think of the bay, rivers, ocean, beach towns, cool breezes, or overall fun of summer. One thing is for certain though: the region's people and places have played significant roles throughout American history, dating back to its earliest indigenous inhabitants and European settlers.

The Raritan Bayshore will introduce you to a number of notable people, places, and events taken from the communities of South Amboy, Perth Amboy, Middletown, Matawan, Aberdeen, Keyport, Union Beach, Keansburg, Holmdel, Hazlet, Atlantic Highlands, Highlands, Sayreville, Old Bridge, and Woodbridge. We hope you enjoy exploring our "hometowns" and share our enthusiasm for a place where history, entertainment, and outdoor fun come together.

One

COMMUNITY

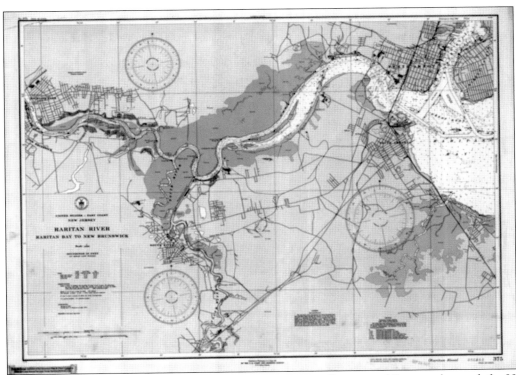

The Raritan River originates as a spring-fed stream in Morris County and flows to the south for 23 miles, blending with other smaller rivers and streams for another 31 miles until it reaches Raritan Bay off the shores of Perth Amboy. Throughout history, this waterway has been important to the growth of central New Jersey and the five boroughs of New York City. (Author's collection.)

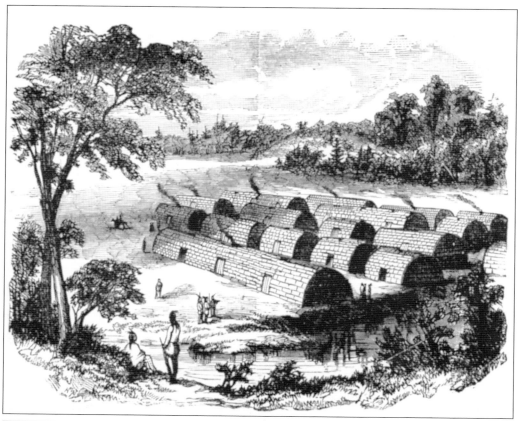

The Leni Lenape were Woodland Native Americans who lived in communities throughout the Raritan Bay region. Members of the tribe lived in shelters ranging from wigwams constructed with saplings covered with bark to longhouses that could provide shelter for several families. To sustain their communities, the Lenape hunted, fished, and gathered wild plants, nuts, and seeds. The arrival of European settlers to the region led to their removal from ancestral lands. (Author's collection.)

Henry Hudson was searching for trade routes to Asia when he arrived in the Raritan Bay in 1609. Hudson moored his ship *Halve Maen* in the bay, and in a short time, his crew was interacting and trading with the Lenape. Members of Hudson's crew were later attacked by two dozen Lenape in canoes. Soon after, members of Hudson's crew and the Lenape came into conflict with one another. Despite this tension, the two groups opted to continue to trade before Hudson and his crew departed the bay. (Author's collection.)

Giovanni da Verrazzano was the first European who entered the Raritan Bay and New York Harbor in 1524 as part of an expedition funded by King Francis I of France. Verrazzano sailed along the coast of New Jersey and called the area Lorraine. On entering Raritan Bay, he noticed numerous geographic features, including the highlands along the edge of the bay. He also made contact with the local indigenous people. (Author's collection.)

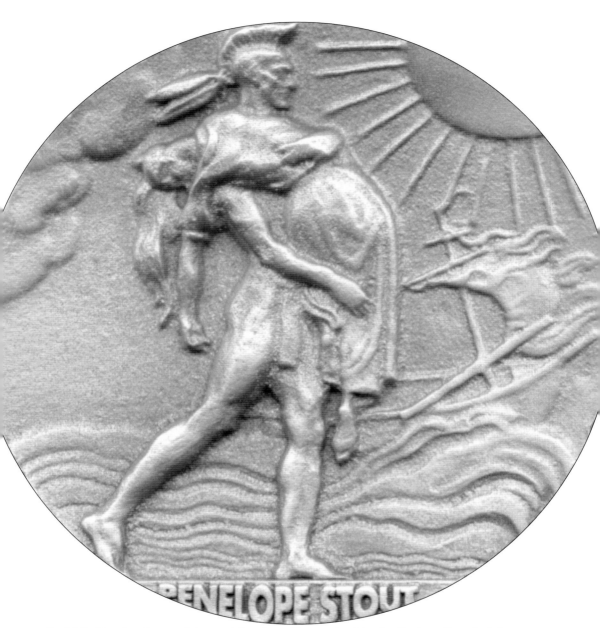

PENELOPE STOUT

In 1643, Dutch colonists John and Penelope Kent arrived in the Raritan Bay. As John was too ill to travel, crewmembers helped the couple into a small boat bound for Sandy Hook. There, John was killed while Penelope was wounded and taken prisoner by the Leni Lenape. After her release, Penelope continued to New York, where she married Richard Stout, eventually settling in the Middletown area. She is considered by some historians to be the first European woman to settle in New Jersey. (Author's collection.)

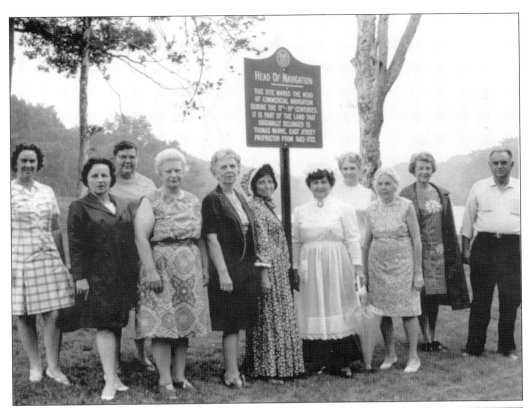

A historical marker on County Road 516 in Old Bridge marks the site of the head of commercial navigation that began in colonial East Jersey during the 17th century and lasted into the 19th century. The marker stands on property once owned by prominent merchant Thomas Warne, East Jersey proprietor from 1683 to 1722. Warne controlled considerable land holdings in the region, including a 1,000-acre plantation in present-day Matawan and Old Bridge. (Madison–Old Bridge Township Historical Society.)

In the late 17th and early 18th centuries, cargo and passenger ships from Europe passed through the Raritan Bay on their way to and from New York Harbor. The bay became the hunting ground for greedy pirates. Edward Teach, better known as Blackbeard, conducted raids from Raritan Bay to intimidate business and ship owners in Middletown. In some instances, local residents worked with the pirates and benefitted from their nefarious activities. (Author's collection.)

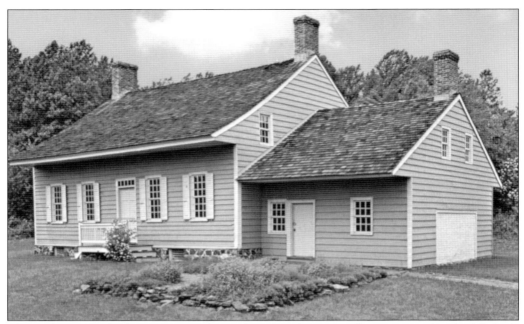

The Holmes-Hendrickson House is located in the Pleasant Valley section of Holmdel. Built around 1754 by the prominent Holmes family, the house is a combination of Georgian and Dutch architecture. Originally the house stood just over a mile from its current location near Holmdel Park. Bell Telephone Laboratories acquired the general property area and moved the historic house to a small lot near the original location. (Author's collection.)

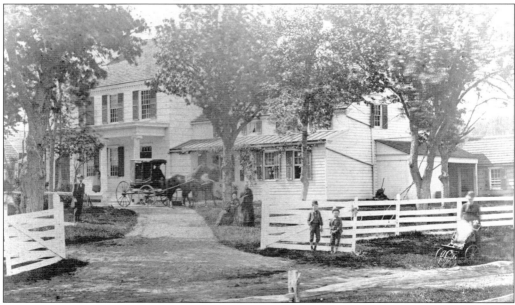

Located in Holmdel Park, Longstreet Farm (pictured around the 1880s) serves as an example of life in rural Monmouth County during the late 19th century. The Dutch Cottage section of the farmhouse dates back to 1775, with other sections added to the original structure in the 19th century. (Monmouth County Park System.)

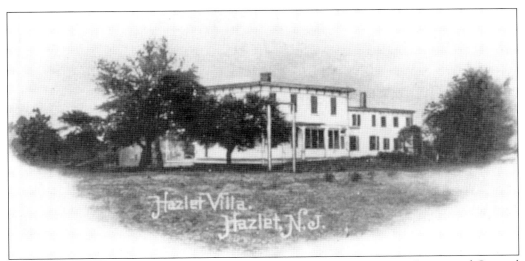

Hazlet was created in 1848 as Raritan Township by an act of the New Jersey Senate and General Assembly. In a 1967 general election, the residents changed the name to Hazlet Township. The name Hazlet derives from a prominent mid- to late-19th-century landowner, Dr. John Hazlett, who held considerable land holdings in the southern part of the township that were used for a new rail line. (Author's collection.)

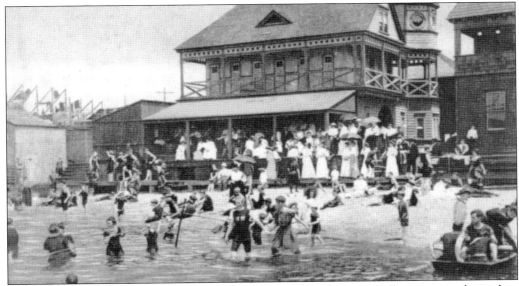

In the late 19th century, Sandy Hook became a popular site for city dwellers to enjoy themselves in the summer. In 1881, the Reckless family purchased prime beach real estate along the Atlantic Ocean stretching to the shores of the Shrewsbury River. Highland Beach, located directly across from Highlands, became a major resort with different amusements and buildings in the popular Victorian style of architecture. (Author's collection.)

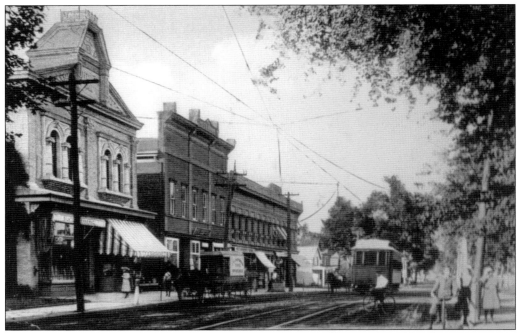

The path that became Main Street in Matawan was originally a trail used by the Matovancon Indians leading from the central area to the Bayshore. Through the centuries, the path became a street that reflected in architecture the different colonial, Victorian, and modern building styles. A variety of public buildings, commercial enterprises, churches, stately mansions, light industry, and transportation resources were developed over time. (Author's collection.)

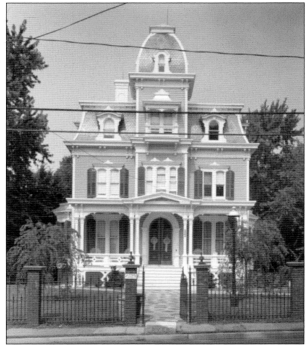

David G. Ryer was a New York textile merchant who built this towering blue home on Matawan's Main Street in 1873. Ryer went on to become an important figure in local government, serving as the chairman of the Matawan Township Committee from 1892 to 1895. This iconic Matawan home is a fine example of the French Second Empire architectural style. (Library of Congress.)

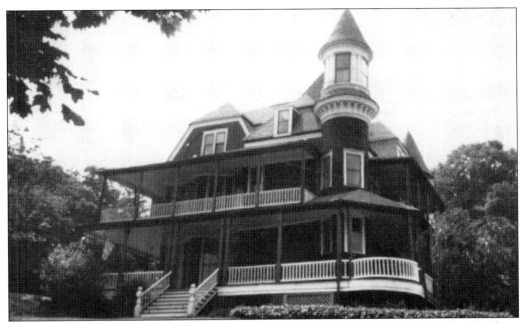

The Strauss Mansion was built in 1893 by New York merchant Adolf Strauss. The building, constructed to serve as the Strauss family summer home, is three stories high with two large towers, 21 rooms, and 70 windows and overlooks Sandy Hook Bay. Atlantic Highlands became a popular location for elaborate summer homes with a special pier constructed for steamboats coming from New York. (Randall Gabrielan.)

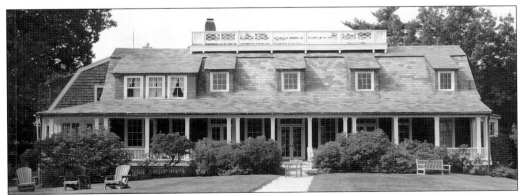

The Water Witch Club Casino was built in 1905. The building, which is in the National Register of Historic Places, is situated on top of one of the highest points on the Eastern Seaboard. It has a sweeping view of Sandy Hook Bay and the New York City skyline. It is one of the oldest casino spaces and has been used continuously for social functions and celebrations. (Author's collection.)

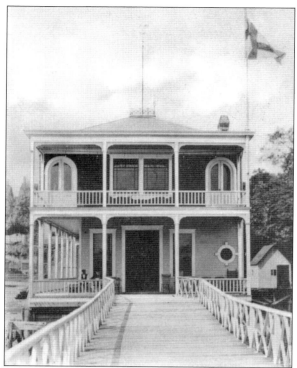

Perth Amboy's Raritan Yacht Club was born in 1882 out of two previously established clubs, the Carteret Boat Club (established in 1865) and the Perth Amboy Yacht Club (established in 1874). Since 1916, the club has been housed in the former Thomas E. Cooper Estate, a waterfront Italianate structure. The Raritan Yacht Club is the second oldest club of its kind in New Jersey and one of the oldest in the country. (Author's collection.)

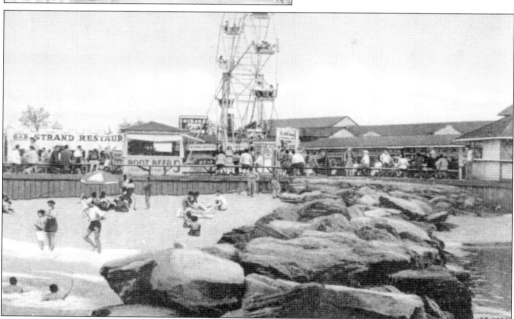

In 1904, William Gelhaus and five other investors sought to establish a resort area along the Raritan Bay waterfront. In 1909, Gelhaus founded the Keansburg Steamboat Company to transport visitors from New York City to the community. These business moves led to the establishment of the first amusements in the community, including a Ferris wheel that would become the Keansburg Amusement Park. (Author's collection.)

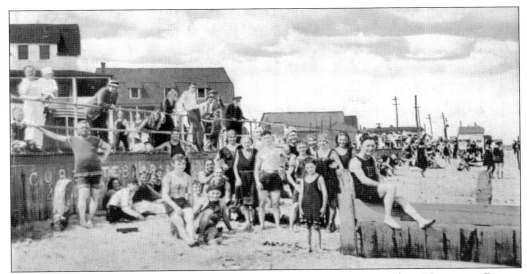

Keansburg was a popular resort town from the early 1900s to 1960, when Hurricane Donna wiped out much of the waterfront infrastructure. Tourists, many of whom were from New York City, would flock to Keansburg's beaches to cool off in the summer months. After the Gelhaus family helped to create the Keansburg Steamboat Company in 1910, the area saw an influx of New Yorkers purchasing homes in town. (Author's collection.)

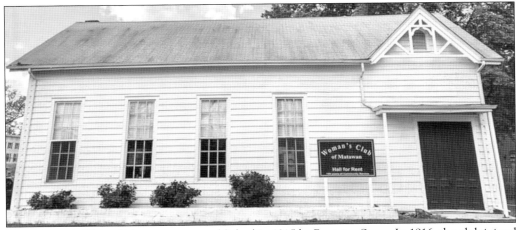

The Woman's Club of Matawan was established in 1915 by Beatrice Stern. In 1916, the club joined the New Jersey Federation of Woman's Clubs. The members were very active in supporting the troops during World War I and providing relief measures during the 1918 Influenza Pandemic. Over the 100 years of its existence, members of the club have done their part to promote local charities and public improvements. (Lisa Stein.)

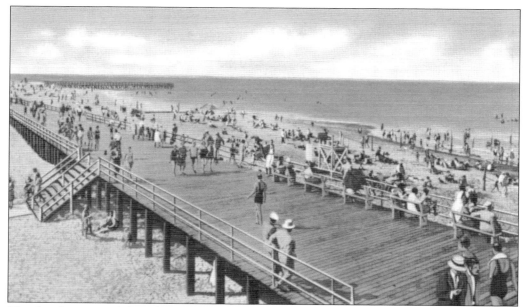

The development of the Cliffwood Beach area in 1924 included a mile-long boardwalk with bathhouses and beach lockers. The boardwalk and other amenities were popular for summer tourists, especially those traveling to the community from northern New Jersey and New York City. The boardwalk and its associated amusements were ultimately destroyed by a series of hurricanes throughout the 1950s and in 1960. (Author's collection.)

Treasure Lake is a small body of water located at the end of the site of the former Cliffwood Beach Boardwalk. The new name was used because of a local legend about Capt. William Kidd's buried treasure deposited around this small lake. Many people have looked, but no one has found the treasure, allegedly hidden in the dead of night by the fierce pirates. (Author's collection.)

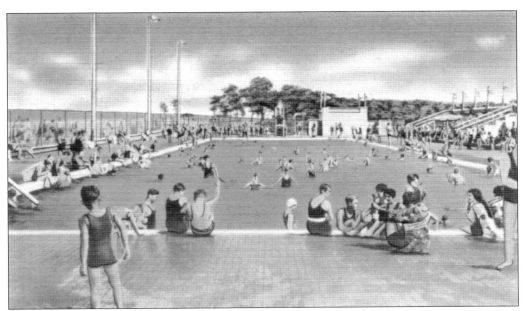

From the early 1900s until 1960, Cliffwood Beach was a bustling shore town complete with a boardwalk and amusements. Opened in 1929, the saltwater swimming pool at Sportland was a popular summer tourist destination. "Jersey's Finest Pool" held 500,000 gallons of water and was open for day and evening swimming thanks to the installation of floodlights. Much of the community's beachfront infrastructure was destroyed by a series of hurricanes, including Hurricane Donna in 1960. (Author's collection.)

THE CLUB HOUSE.

Laurence Harbor is named for developer Laurence Lamb. At the turn of the 20th century, Lamb established a 400-acre shorefront golf and country club. Among those who frequented the club were Clark Gable, Guy Lombardo, the Prince of Wales, and the Vanderbilts. They came to party and eat Chingarora oysters, for which Raritan Bay was famous. In 1928, the land was sold to developers for the construction of bungalows. (Author's collection.)

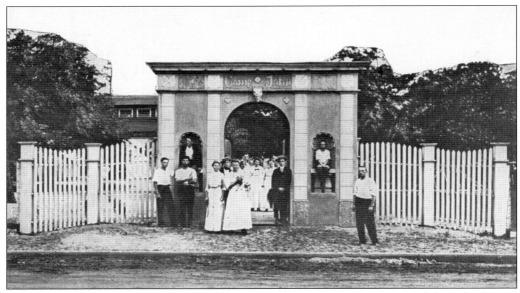

Located on Carr Avenue in Keansburg, Camp Jahn was a popular private club and vacation destination for German Americans, especially athletes and outdoorsmen, in the early 1900s. Named for its founder, the camp was composed largely of pitched tents and bungalows but, over time, also included a large pavilion, beer hall, and streets running through the colony. (Author's collection.)

Lake Lefferts was formed in 1928 by building a dam to control the flow of Matawan Creek. The lake was named for Jacob R. Lefferts, a prominent lawyer and developer in town. This beautiful lake has been used for boating, swimming, and as a gathering place for an annual fireworks display and other town events over the years. (Author's collection.)

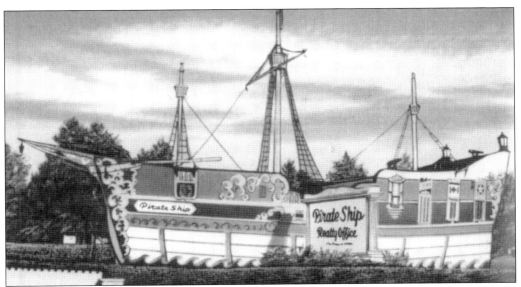

This realistic replica of a pirate ship was created for a local property realtor. It was quite an attraction and helped to sell many lots in Cliffwood Beach. The original pirate ship was later moved farther north away from Cliffwood Beach. For years, this landmark reminded many residents, especially children, of the stories and legends of actual pirates, such as Captain Kidd, that frequented the Raritan Bay region. (Author's collection.)

Opened in 1940, Cheesequake State Park is a New Jersey state park that covers 1,610 acres of land in Old Bridge. The park's name was derived from the Lenape word *chiskhakink*, which means "upland," "upland village," or "at the land that has been cleared." The park offers a number of recreational activities to visitors throughout the year, including hiking, mountain biking, camping, swimming, boating, sledding, cross-country skiing, and snowshoeing. (Peter Lloyd.)

Holmdel Park was acquired by the Monmouth County Park System in 1962. The 664-acre park provides nearly one million visitors a year with a number of amenities, including the David C. Shaw Arboretum, fishing, picnic areas, tennis courts, 10 miles of trails, playgrounds, ice skating, sledding, and a cross-country running trail. The park is home to two historic sites: Historic Longstreet Farm and the Holmes-Hendrickson House. (Author's collection.)

The purchase of about 225 acres of woods, vacant land, and a lake in Hazlet in the 1980s provided for the creation of Natco Park, an area protected by the state's Green Acres Program. The park, considered a freshwater wetland, is home to diverse wildlife such as nesting and resting migratory birds. It includes marshes, a bog, stream, and a three-acre lake that was once a quarry. (Author's collection.)

Constructed in 1992, this trail is named for explorer Henry Hudson. The Monmouth County Park System trail runs from Freehold to Marlboro and Aberdeen and then to Atlantic Highlands. It is a paved 24-mile-long and 10-foot-wide trail on a former railroad right of way. The trail is used by runners, bikers, walkers, and nature lovers. (Author's collection.)

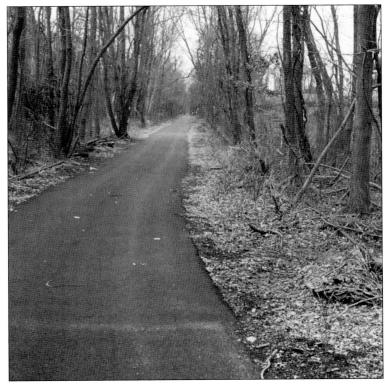

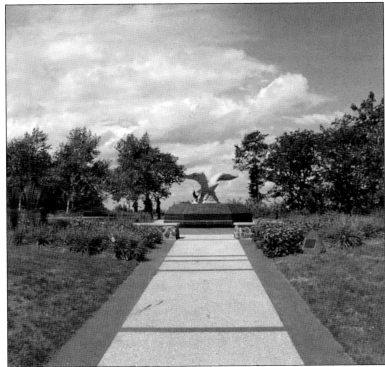

At 266 feet, Mount Mitchill in Atlantic Highlands sits on the highest natural elevation on the Atlantic seaboard from Maine to the Yucatan in Mexico, excluding islands. It provides beautiful views of Raritan Bay and the New York skyline. A special 9/11 memorial, a tribute to local people who lost their lives during the terrorist attack in New York City, is located here. (Author's collection.)

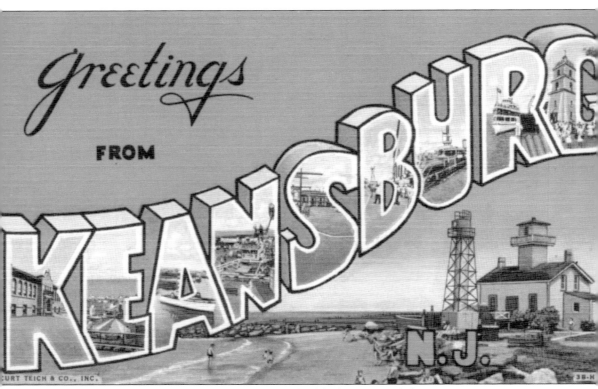

This "Greetings from Keansburg" postcard highlights some of the community's top tourist attractions. Postcards in this style were extremely popular souvenirs for summer tourists throughout the communities of the Jersey Shore. (Author's collection.)

Two

GOVERNMENT
AND POLITICS

Known as the oldest public building in continuous use in the United States, the Perth Amboy City Hall was built between 1714 and 1717. Despite undergoing several architectural renovations throughout history, portions of the original structure still exist today. From 1789 to 1790, the New Jersey Legislature met there, becoming the first state legislature to ratify the Bill of Rights on November 20, 1789. (Author's collection.)

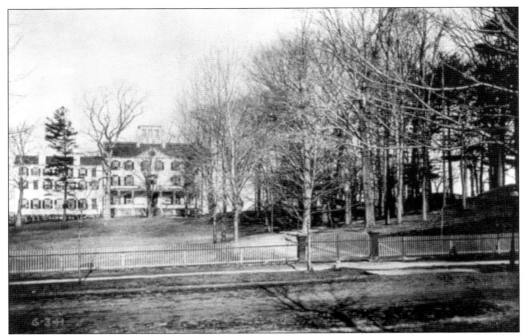

The only official British royal governor's mansion still intact from colonial days is located in Perth Amboy. The Proprietary House (also known throughout history as the Brighton Hotel, the Bruen House, and the Westminster) was constructed between 1762 and 1764. This building is best known for being the home of the last royal governor of New Jersey, William Franklin, who moved into the mansion with his wife in 1774. (Author's collection.)

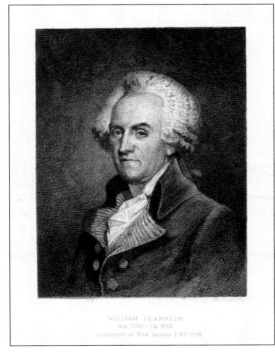

WILLIAM FRANKLIN.
Nat 1730 - Ob 1813
Governor of New Jersey 1762-1776

The acknowledged illegitimate son of Benjamin Franklin, William Franklin resided in the Proprietary House until 1776, when he was arrested by Patriots for his loyalty to Great Britain during the American Revolution. After his release, Franklin became a leading figure in New York and New Jersey Loyalist circles before his departure to Great Britain in 1782. There, he died in 1813, having never reconciled with his father. (Author's collection.)

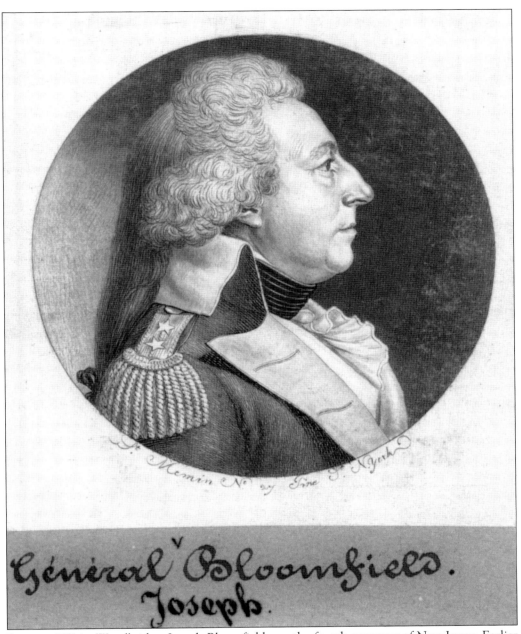

Général Bloomfield.
Joseph.

Born in 1753 in Woodbridge, Joseph Bloomfield was the fourth governor of New Jersey. Earlier in his life, he served as a captain in the Continental Army during the Revolutionary War. After the war, he led federal and New Jersey troops to put down the Whiskey Rebellion in 1794 near Pittsburgh, Pennsylvania. He served two terms in the US House of Representatives before he became governor. (National Portrait Gallery.)

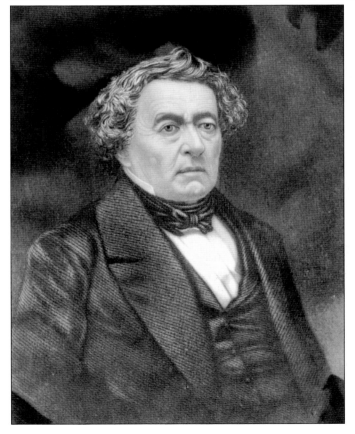

Perth Amboy's Kearny Cottage was built around 1780 and served as the home of two notable US Navy officers: Capt. James Lawrence and his nephew Commodore Lawrence Kearny. Captain Lawrence, who was killed in action while commanding the USS *Chesapeake* during the War of 1812, is remembered for his famous last words: "Don't give up the ship!" (Library of Congress.)

Commodore Lawrence Kearny served in the US Navy from 1807 to 1861, seeing action in the War of 1812 as well as in a number of expeditions against pirates. During the Opium War (1839–1842) between Great Britain and China, Kearny was sent to China to defend American trade interests. He served as mayor of Perth Amboy from 1848 to 1849. (US Naval Institute.)

Henry Stafford Little was born in Middletown Point (now Matawan) on August 17, 1823. Following his graduation from the College of New Jersey (now Princeton University) in 1844, Little went on to practice law. He later found success and fortune as the president of the New York & Long Branch Railroad. An influential figure in the Democratic Party, Little served in the New Jersey Legislature from 1864 to 1871. (Author's collection.)

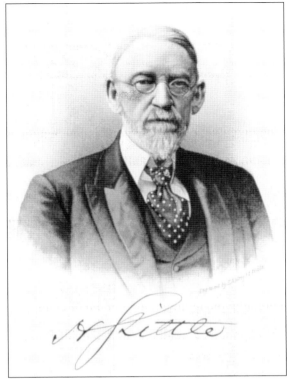

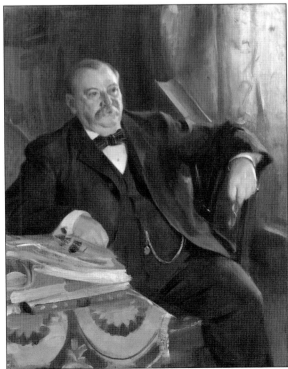

A trustee and major donor to Princeton University, Henry Stafford Little died in Trenton on April 24, 1904, and is interred at Matawan's Rose Hill Cemetery. Among his honorary pallbearers were former president Grover Cleveland (pictured), future president Woodrow Wilson, former senator James Smith Jr., Sen. John Kean, and Sen. John F. Dryden. (National Portrait Gallery.)

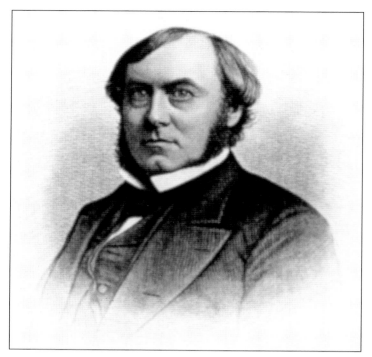

Joseph Dorsett Bedle was born on January 5, 1831, in Middletown Point (present-day Matawan). He was educated in his hometown and went on to read law in Trenton. Admitted to the bar in 1853, he was appointed a justice of the state supreme court in 1865. A Democratic convention nominated him as its candidate for governor in 1874. Bedle defeated a very popular competitor and was inaugurated in January 1875. (Author's collection.)

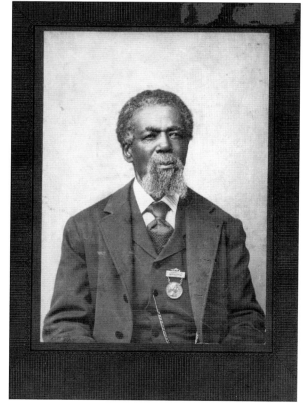

Thomas Mundy Peterson was born on October 6, 1824, in Metuchen, New Jersey. On March 31, 1870, Peterson was the first African American to vote in an election under the recently enacted provisions of the 15th Amendment of the US Constitution at the Perth Amboy City Hall. In New Jersey, March 31 is celebrated as Thomas Mundy Peterson Day. He was presented with a gold medal (pictured) in honor of his vote by the citizens of Perth Amboy on May 30, 1884. (Perth Amboy Free Public Library.)

Garret Hobart was born in Long Branch on June 3, 1844, and grew up in nearby Marlboro. In 1896, Hobart was elected vice president under Pres. William McKinley. While in office, he died of heart disease on November 21, 1899. One of the academic stops on Hobart's ascent to the second-highest office in the land was a prominent and coeducational academy in Matawan, Middletown Point Academy (later Glenwood Institute). (Library of Congress.)

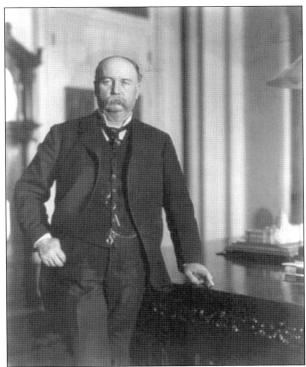

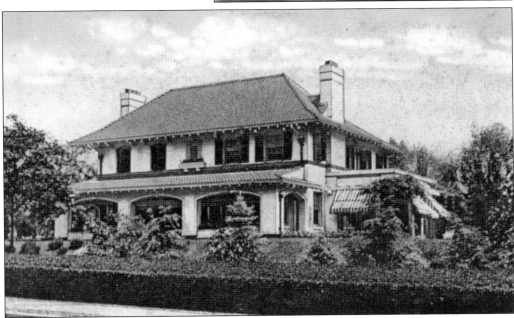

Henry Stafford Terhune (1859–1942) was a state senator and judge from Matawan. A graduate of the College of New Jersey (later Princeton) and Columbia Law School, Terhune built a mansion on Main Street in 1911. In 1930, Terhune donated the land that became Terhune Park on Main, South, and Broad Streets to Matawan Borough. This donation of land was accompanied with a generous gift of $1,000 to beautify the park. (Author's collection.)

Born in Brooklyn on November 3, 1865, James Paul Maher served as a US congressman from New York (1911–1921). The former hatter and union leader later entered the real estate field, settling in Keansburg. There, Maher served as mayor between 1926 and 1927 before being recalled due to voter dissatisfaction with the municipal budget and taxes. Maher died in 1946 and is interred at St. Joseph Cemetery in Keyport. (Author's collection.)

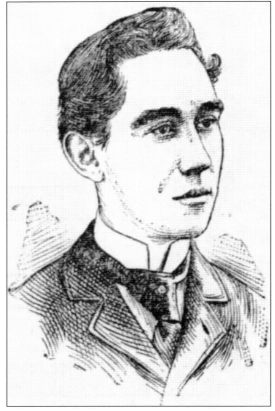

Thomas Joseph Scully represented New Jersey's Third Congressional District for five terms (1911–1921). Born in South Amboy on September 19, 1868, the Democrat began his political career in local politics in South Amboy. He served as a delegate to the 1912 Democratic National Convention, where Woodrow Wilson was selected as the party's presidential nominee. Following his retirement from Congress, Scully served briefly again as mayor of South Amboy until his death in 1921. (Author's collection.)

Harold Giles Hoffman was born in South Amboy on February 7, 1896. Hoffman was elected to represent New Jersey's Third District in the US Congress from 1927 to 1931. He served as governor of New Jersey between 1935 and 1938. In 1954, while serving as the director of the state's Unemployment Compensation Commission, Hoffman confessed in writing to playing a significant role in an embezzlement scheme. He died soon after and is buried in Christ Church Cemetery in South Amboy. (Author's collection.)

William Halstead Sutphin served two terms as the mayor of Matawan and six terms as a US congressman (1931–1943). He was in the New Jersey National Guard during the Pancho Villa expedition (1916) on the US southern border. During World War I, he was an officer in the Army Air Corps. After the war, he organized Matawan's American Legion Post 176. He is buried in Arlington National Cemetery. (Author's collection.)

Union Beach is located on the banks of Raritan Bay between Keyport and Keansburg. Harry McCandless, a Spanish-American War veteran, was important in creating vital public services. Education services began in this humble schoolhouse. The borough hall was a favorite gathering place in part because of a historical bronze plaque that was placed on the lawn honoring Richard Poole, a Revolutionary War and War of 1812 veteran. (Author's collection.)

Craig Coughlin was born on January 31, 1958, in Perth Amboy. A product of the South Amboy public schools, he received his bachelor's and law degrees from St. John's University. On January 12, 2010, the Democrat assumed office as a member of the New Jersey General Assembly representing the 19th Legislative District. Coughlin became the 171st speaker of the New Jersey General Assembly on November 9, 2019. (Craig Coughlin.)

Born in Perth Amboy on June 28, 1962, John Wisniewski represented the 19th District in the New Jersey General Assembly from 1996 to 2018. Before obtaining a bachelor's degree from Rutgers University and a law degree from Seton Hall University, Wisniewski attended Sacred Heart Elementary School in South Amboy and Sayreville War Memorial High School. Wisniewski was appointed deputy speaker of the New Jersey General Assembly in 2004. (John Wisniewski.)

Gerry Scharfenberger began his career in politics as the mayor of Middletown. Since then, he has served as a Monmouth County freeholder and member of the New Jersey General Assembly from the 13th District. An archaeologist by trade, Scharfenberger received his doctorate in anthropology from the City University of New York. He has participated in archaeological excavations throughout the Bayshore region and currently serves as an instructor of anthropology at Monmouth University. (Gerry Scharfenberger.)

Robert D. Clifton has served as a member of the New Jersey General Assembly from the 12th District since 2012. A member of the Republican Party, Clifton previously served as mayor of his hometown, Matawan, and on the Monmouth County Board of Chosen Freeholders. A graduate of St. John Vianney High School in Holmdel, Clifton holds college degrees from Rider University and the University of Richmond. (Robert D. Clifton.)

Three

BUSINESS

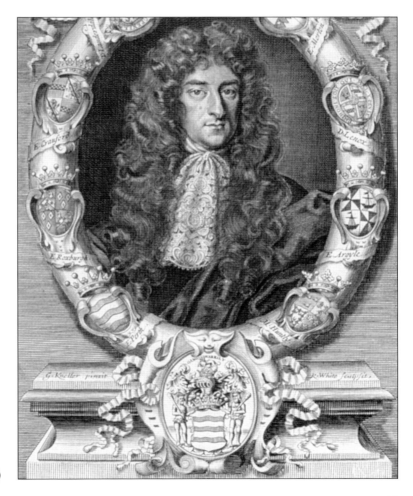

The city of Perth Amboy is in part named after a Scottish nobleman who lived from 1648 to 1716. Despite never stepping foot on the land that would become the state of New Jersey, James Drummond, Fourth Earl of Perth, was one of a group of proprietors who owned a large parcel of property that would later make up much of New Jersey. (Author's collection.)

A partner of notable Quaker leader and fellow proprietor William Penn, James Drummond, Fourth Earl of Perth, sponsored an expedition to East New Jersey in 1684. In honor of his contributions to the city and state, a statue of the earl was erected near the Perth Amboy City Hall in 1983. (Author's collection.)

In 1714, the Kearney family settled in present-day Keyport. They had an 800-acre plantation called Key Grove Farms. In addition to farming, their main sources of income were oyster harvesting, timber, and shipping. The Kearney Mansion changed ownership over the years until it was abandoned in 1972. Before it was demolished, concerned citizens salvaged a number of items from the house that would become part of the Keyport Historical Society's collection. The Keyport Historical Society is pictured. (Keyport Historical Society.)

The Jonathan Singletary Dunham House, located in Woodbridge Township, was built around 1709 by Jonathan Singletary Dunham, an early American settler and freeholder who built the first gristmill in New Jersey. It is the oldest building in Woodbridge Township and was originally part of a 213-acre farm. The house was built with brick from Holland that was formerly used as ballast for ships. (Author's collection.)

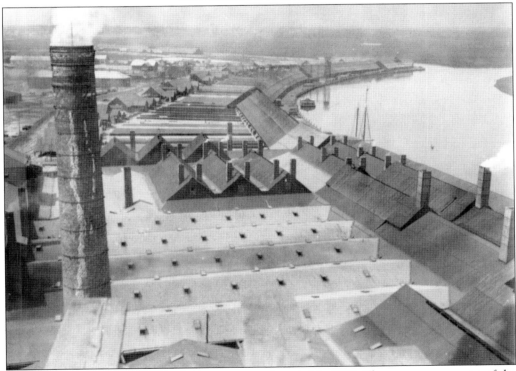

Sayreville's Sayre and Fisher Brick Company was founded in 1850. The company was one of the largest brick manufacturers in the world, as it was located next to the Raritan River, where barges could carry the bricks into the Raritan Bay to facilitate further distribution. The plant closed in 1960, but records indicated an estimated six billion bricks had passed through the factory. (Randall Gabrielan.)

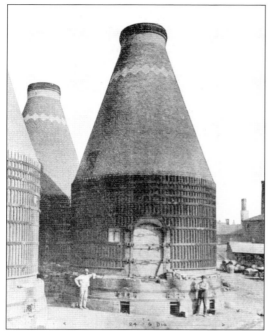

Rich clay deposits were left by the receding glaciers in New Jersey 21,000 years ago, later supporting the creation of terra-cotta, a type of earthenware that can be used for sculpture or ornamental decorations. Several factories producing terra-cotta appeared in Perth Amboy in the mid- to late 19th century. Terra-cotta factories ended production in Perth Amboy in the 1960s. Pictured here are three kilns owned by the Perth Amboy Terra Cotta Company. (Author's collection.)

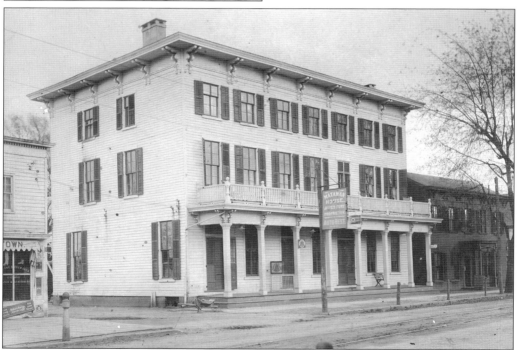

Over the course of its history, Matawan House was a hotel, restaurant, bar, and police station. Located on Main Street, the oldest part of the building was constructed by the Ten Eyck brothers during the 1850s. Following Prohibition, the building was no longer used as a hotel. Failed attempts to convert the structure into an office building led to its demolition in 1930. (Monmouth County Historical Association.)

The National Fireproofing Company (Natco) mined clay that helped produce heat-resistant bricks used for insulation, ceramics, and ovens in Union Beach through the 1930s. The clay was removed from the mine using various methods, one of which accidentally uncovered an underground spring, which flooded the bottom of an open mine. The miners were unsuccessful in trying to remove the water, leading to the creation of Natco Lake. (Author's collection.)

Oschwald Brick Works Developed Jefferson Colonial; Many Buildings Beautified By Cliffwood Firm's Output

Supplying an extensive demand and offering the type of products and service that leave nothing to be desired, Oschwald Brick Works, Inc., of Cliffwood, has instituted many important measures in its work to gain and hold its present position of consequence.

One of the most noteworthy achievements of the firm was the development of Jefferson Colonial brick, a combination of the blue and yellow clay from which the firm makes its bricks.

Old Virginia Colonial bricks, with their delicate salmon pink shade, attracted the attention of Paul Oschwald, directing head of the firm, and he found that by mixing the yellow and blue clay he was able to match the hue of the popular face bricks and widen his scope of service by providing for increased demand.

The post office at Dover, N. J., required 65,000 of these bricks, while four other similar structures have been beautified with them and 25 post office buildings were built with Oschwald back brick.

Since 1909 the firm has been under the management of Oschwald interests. Joseph Oschwald, father of the present head, purchased the business from Bushnell-Lupton Company in 1909 and from the time large-scale production started with the aid of new and modern equipment four years later Paul Oschwald has been in charge. He purchased the interests of his brothers three years after his father's death.

With a capacity production of 125,000 bricks a day, the plant supplies builders in New Jersey, New York, Pennsylvania, Delaware, Maryland and Virginia.

Mr. Oschwald is a member of New Jersey Manufacturers Association.

Due to the very significant clay deposits in the Raritan Bayshore region, the brick-making industry became an important source of local revenue. The Oschwald Brickworks in Laurence Harbor began operation in the early 1900s and continued to thrive until the early 1960s. Its 60 workers produced more than 84,000 bricks per day. The brickworks were demolished to provide room for residential dwellings. (Author's collection.)

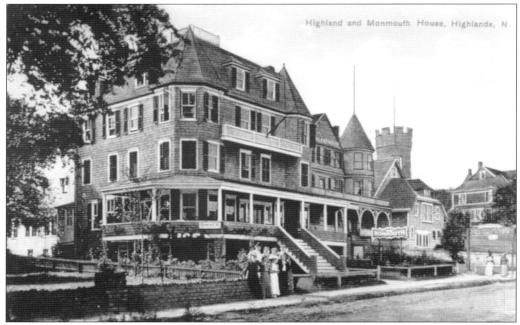

With indications of a growing summer tourist boom during the early 20th century, a number of fine hotels popped up in Highlands during this period. The Monmouth House, built in 1903 along Navesink Avenue, was one of these hotels. Next door to the Monmouth House was another grand hotel of the community, Highland House (built around 1898). (Author's collection.)

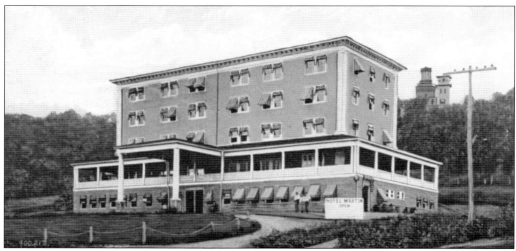

The Hotel Martin (also known as the Martin Hotel and Martin House) was another example of a hotel built during this period of rising summer tourism. Martin Gerbrach built his hotel at the corner of Portland Road and Highland Avenue near the bridge leading into town in 1906. (Author's collection.)

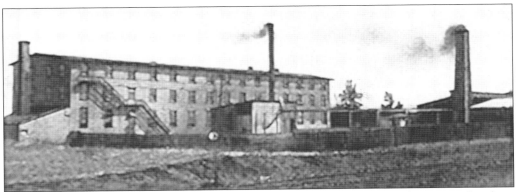

Hanson–Van Winkle–Munning Company was an important contributor to the Raritan Bayshore region's economy. The firm, located in Matawan, began in 1911 to make electroplating and buffing equipment. During World War II, the company played a vital role in contributing to the war effort. (The *Matawan Journal*.)

Wesley F. Hall, chief design engineer of the Hanson–Van Winkle–Munning Company, helped to solve a critical technical problem, supporting the development of the atom bomb. Hall helped scientists working on the atom bomb to find a strip-plating process that would adjust to the complexities of the elements making up the bomb. Hall received a special citation from the US government in recognition of his support for the Allied victory. (The *Matawan Journal*.)

Matawan Firm Did Work For A-Bomb

H-VW-M Co. Overcame Difficulty Blocking Manhattan Project; W. F. Hall Engineer

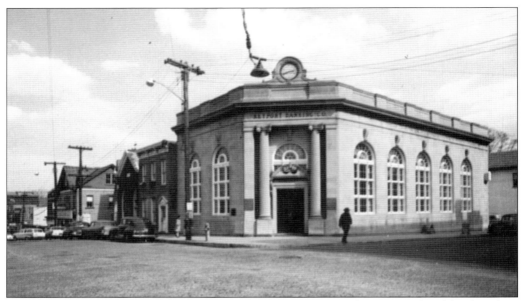

The historic bank building in Keyport has a wonderful past and remains a local landmark to this day. The town of Keyport was known for its oyster industry, one of the largest in the world until overfishing and pollution led to its collapse in the middle of the 20th century. The original owner of the bank building, Ellsworth Oyster Company, used the building to store supplies. (Author's collection.)

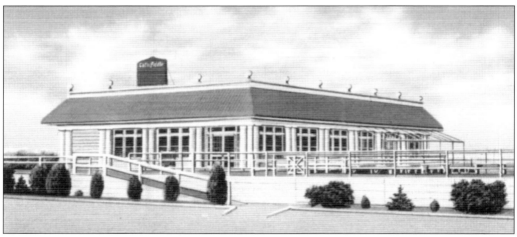

Opened in 1927, the Cat'n Fiddle was a popular cocktail bar and lounge on the Cliffwood Beach Boardwalk. One of the many attractions that catered to locals and tourists alike, this fixture of the community remained open even after Hurricane Donna and its ensuing damage crippled the former resort town's economy in 1960. (Author's collection.)

Constructed in 1956, "the Evil Clown of Middletown," or "Calico," served as a sign for the now-defunct Food Circus grocery store on Route 35. The clown's sinister smile has contributed to its popular moniker over the years. The Evil Clown of Middletown was designed and painted by New Jersey–based artist Leslie Worth Thomas, who also created the popular *Tillie* mural in nearby Asbury Park. (Author's collection.)

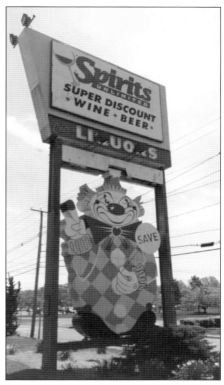

Vintage Vinyl was a popular record store located in the Fords section of Woodbridge. For over 42 years, the store provided customers with a vast selection of music in multiple formats. A number of popular musicians, such as the Gaslight Anthem's Brian Fallon, held meet and greets and in-store performances in the shop and parking lot. With the retirement of founder and owner Rob Roth, Vintage Vinyl closed in 2021. (Author's collection.)

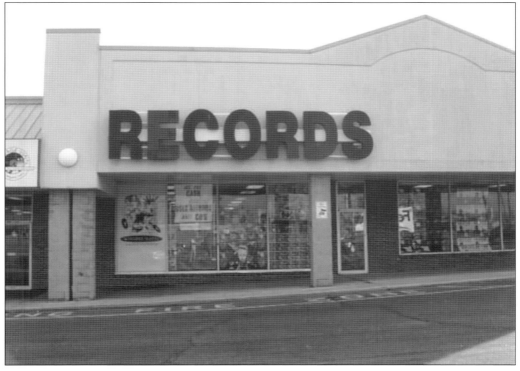

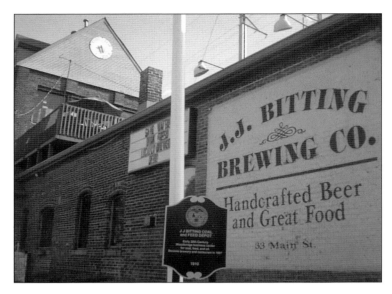

Founded in 1997, J.J. Bitting Brewing Company became the first brewery to operate in Woodbridge Township since the repeal of Prohibition in 1933. The brewery occupies the former J.J. Bitting Coal and Feed Depot, built in 1916, that was once the tallest building in town. The brewery is known for a variety of beer styles ranging from India pale ales to stouts. (Author's collection.)

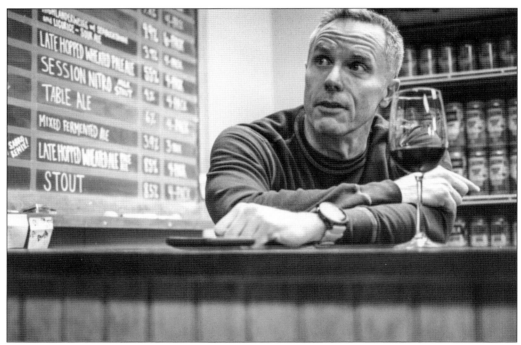

Carton Brewing Company was founded in 2011 by craft brewers and cousins Augie (pictured) and Chris Carton. Headquartered on East Washington Avenue in the Carton cousins' hometown of Atlantic Highlands, the brewery became popular with local beer lovers for a variety of styles including Boat Beer, an American pale ale. Cofounder Augie is also a popular beer podcaster who cohosts the show *Steal This Beer* with author John Holl. (Brian Casse.)

Four

TRANSPORTATION

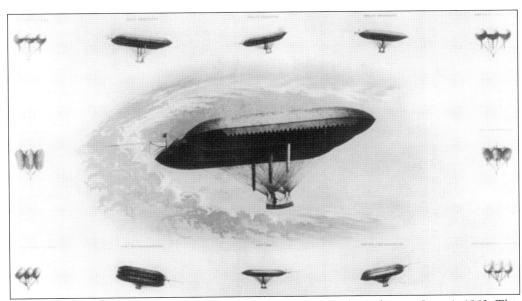

Dr. Solomon Andrews first flew his aircraft, *Aereon*, over Perth Amboy on June 1, 1863. This flight was before the birth of the pioneers of flight, the Wright brothers, thus solidifying the New Jersey resident's place in the history of aviation. (Author's collection.)

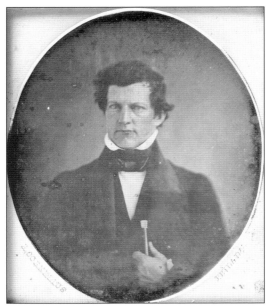

Along with being an aviator, Solomon Andrews, born in 1806, was also a medical doctor and inventor. Not only did he fly *Aereon*, but he also designed and built the dirigible airship. He claimed to pilot his dirigible airship as one would a sailboat. Solomon was also a three-time mayor of Perth Amboy from 1849 to 1855. (National Portrait Gallery.)

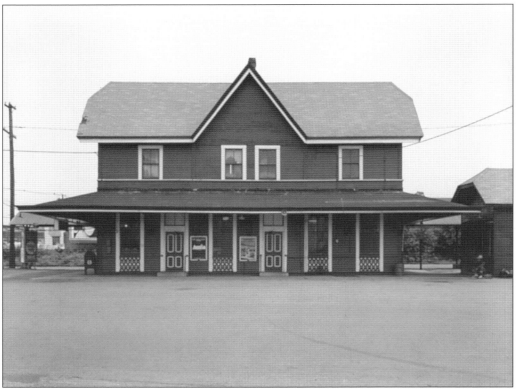

Matawan became a busy railroad junction in the 1870s, and as such, there was demand for a train station. The original Matawan Train Station was built in 1875 as a temporary station. The stick-style depot was in operation until it was replaced with a newer building in 1982. At the time of its closing, it was still classified as a temporary station. (Author's collection.)

The Middletown Train Station was built in 1876 for passenger service. The station, built on land acquired from the Conover family, was constructed to accommodate increased reliance on trains in the region with the expansion of the New York & Long Branch Railroad. The station was refurbished in 1964. The historic landmark became obsolete with the arrival of electric train service in 1988. (Monmouth County Historical Association.)

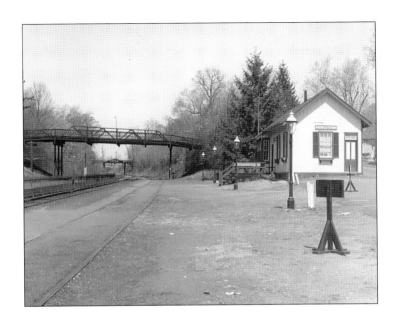

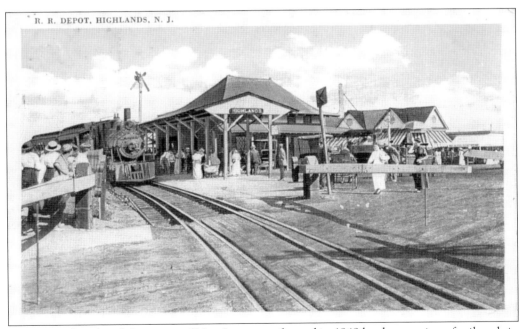

The Central Railroad Company of New Jersey was formed in 1849 by the merging of railroads in the Somerville area. Service began in 1892 and ended in 1958. The Highlands Railroad Station was part of the historic Central Railroad Company of New Jersey that serviced this part of the state. The original Highlands Railroad Station building was constructed in 1900 and was replaced by a shelter in 1951. (Author's collection.)

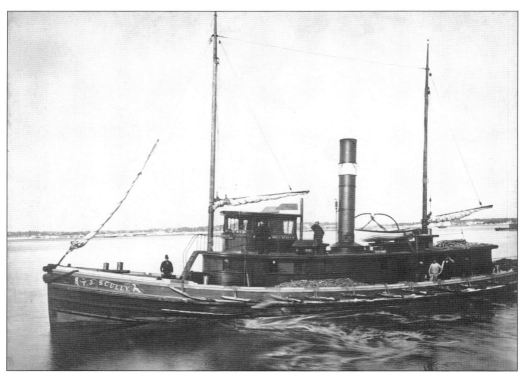

The tugboat *T.J. Scully* is pictured on the Raritan River in South Amboy around 1890. Tugboats serve a vital role in communities that relied upon the maritime industry. These watercraft are used to tow or push large ships and barges. The boat shares its name with notable South Amboy resident and political figure Thomas Joseph "T.J." Scully (see page 34), who engaged in the marine towing and transportation business. (Author's collection.)

Oonuehkoi Bridge, also known as Old Stone Bridge, carries traffic on Mount Avenue over Grand Avenue in Atlantic Highlands. The original wooden bridge was replaced by a stone bridge in 1896. The main promoter, George Lawrie, also president of the Casino Club, named the bridge "Oonuehkoi," claiming it was the name of local Lenape Native Americans in the area. In fact, the word comes from a Massachusetts tribe and means "valley." (Author's collection.)

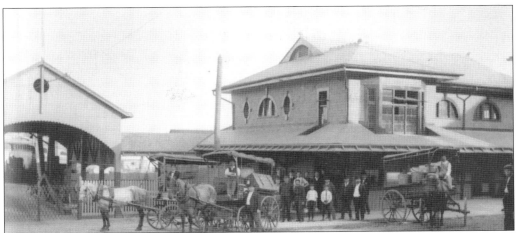

The Perth Amboy Ferry Slip (1904–1964) at the foot of Smith Street on Arthur Kill serviced boats going to and from Tottenville on Staten Island. Ferry services between these locations date back to the late 17th century, when members of the Lenape tribe assisted European settlers. In the early 18th century, Christopher Billopp operated a ferry service there. By the late 19th century, the ferry was steam operated. (Author's collection.)

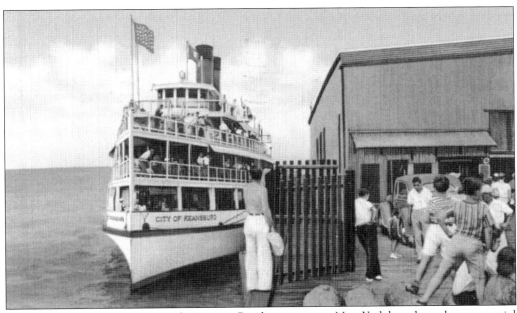

Dependable transportation from the Raritan Bayshore region to New York has always been essential for daily commuters. In 1910, the Keansburg Ferry Service began the era of daily steamboat runs from Keansburg to New York City. The company had a small fleet of steamboats that made three round-trips a day. In 1962, a hurricane destroyed the docking pier, and the service was effectively ended in 1968. (Author's collection.)

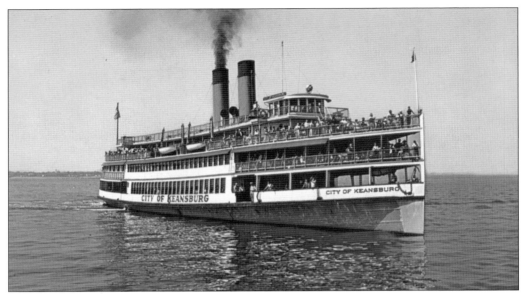

Founded in 1910 by William Alvin Gelhaus, the Keansburg Steamboat Company had a number of ships in its fleets during its tenure. The flagship of the company was the *City of Keansburg*, a 231-foot-long vessel built in Newburgh, New York, in 1926. The ship worked the New York City ferry route until 1962. (Author's collection.)

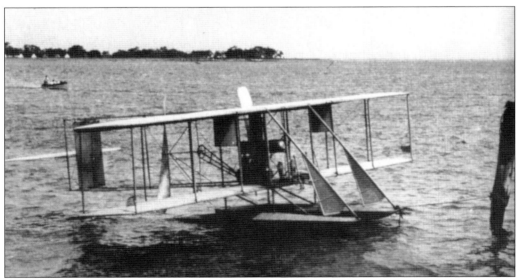

On July 4, 1912, a Wright-Burgess hydro-aeroplane piloted by Oliver J. Simmons departed the water near the coal docks in South Amboy with 1,250 pieces of mail from the South Amboy Post Office bound for the Perth Amboy Post Office. The airplane was modified with pontoons for a water takeoff and landing. The flight was just over one mile and was one of the first airmail flights in the country. (Historical Society of South Amboy.)

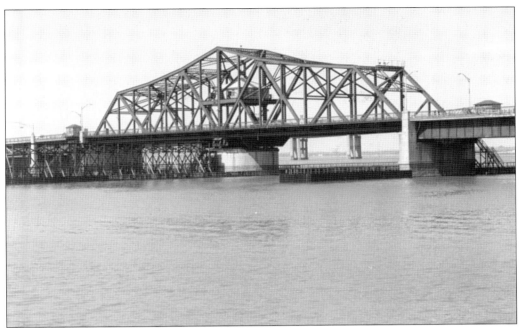

Victory Bridge is a highway bridge that carries Route 35 over the Raritan River, connecting Perth Amboy on the north and Sayreville on the south. The original Victory Bridge (in service 1926–2004) was the largest serving swing span vehicular bridge in New Jersey and a fine example of swing bridge technology. A new Victory Bridge over the Raritan River that opened to traffic in 2005. (Library of Congress.)

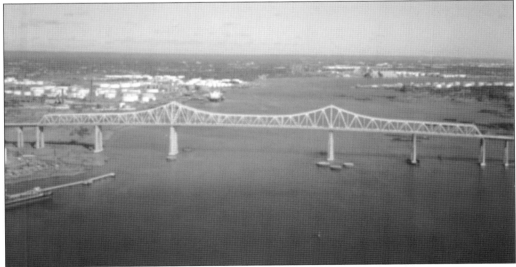

The Outerbridge Crossing connects Staten Island, New York, with Perth Amboy. This bridge is at the southernmost point in New York City leading to New Jersey. This busy commuter toll bridge has an annual traffic volume of 30 million vehicles. The bridge was constructed in 1928 and is an excellent example of a truss cantilever bridge. The bridge was named after Eugenius Harvey Outerbridge, the first chairman of the Port Authority of New York and New Jersey. (Library of Congress.)

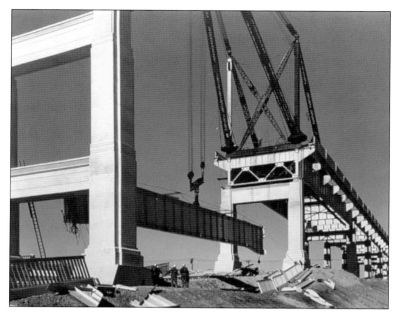

The Thomas Alva Edison Memorial Bridge is located on US Route 9 crossing the Raritan River near the mouth of Raritan Bay. The bridge, which opened in October 1940, connects Woodbridge on the north with Sayreville on the south. It runs parallel to the large Driscoll Bridge, which carries the Garden State Parkway. (New Jersey Department of Transportation.)

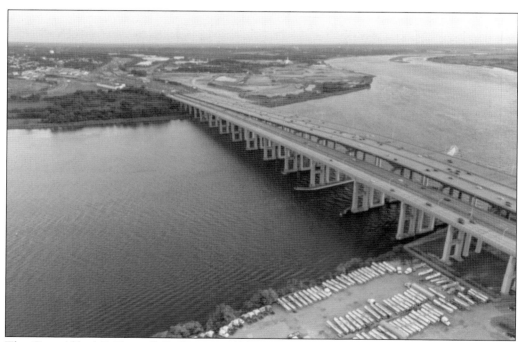

The Gov. Alfred E. Driscoll Bridge is a toll bridge with a series of three spans on the Garden State Parkway spanning the Raritan River near the mouth of Raritan Bay. The bridge connects Woodbridge on the north with Sayreville on the south with a total of 15 lanes of traffic. The bridge was opened in 1954 and is considered one of the busiest commuter bridges in the country. (New Jersey Department of Transportation.)

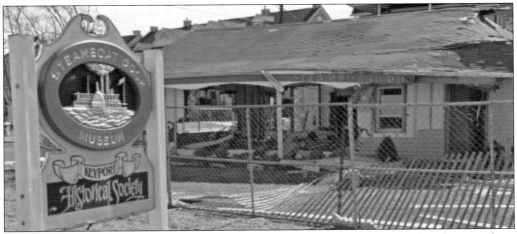

The Steamboat Dock Museum was located in a 1948 building originally owned by the Keansburg Steamboat Company in Keyport. The museum, operated by the Keyport Historical Society, contained a collection of over 4,000 items illustrating the colorful 19th- to early-20th-century steamboat era of transportation from Keyport to New York. The building was destroyed when Hurricane Sandy hit the Jersey Shore in 2012. (Keyport Historical Society.)

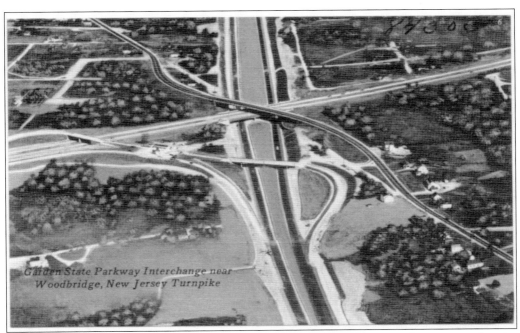

With the significant increase in automobile traffic in the 20th century, residents required major highways to support transportation. The 165-mile Garden State Parkway (established in 1947) was developed to provide north-to-south traffic with many exits and to provide easy access to the Jersey Shore resort areas. The New Jersey Turnpike (established in 1951) was created to provide high-volume traffic a way to cross the state from east to west. (Digital Commonwealth.)

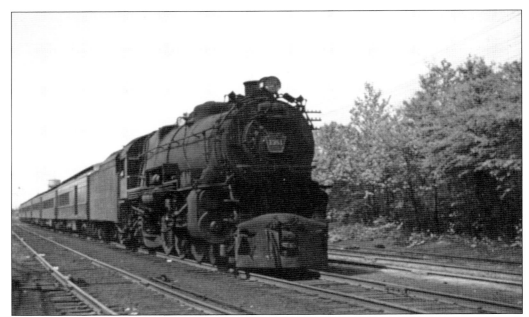

The Pennsylvania 1361, a class K4 Pacific locomotive, speeds along the New York & Long Branch Railroad near South Amboy on May 17, 1955. The New York & Long Branch Railroad, which operated from 1875 to 1976, had stations in several Raritan Bayshore region communities including Perth Amboy, South Amboy, Cliffwood, Matawan, Hazlet, and Middletown. This locomotive is now on display in Altoona, Pennsylvania. (Author's collection.)

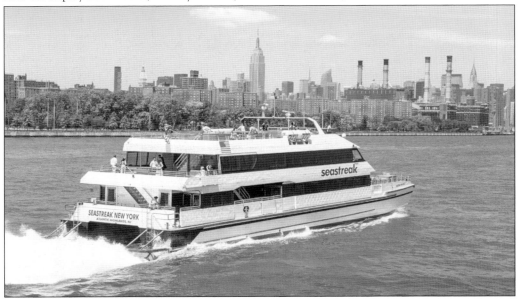

The Seastreak Ferry Company began operation in 1986, servicing the Port of New York, New Jersey, and the Raritan Bay region. The fleet of eight 141-foot vessels are diesel-powered double-hulled catamarans with a capacity for 505 passengers that travel at a speed of 38 knots. After Hurricane Sandy, the company offered special temporary ferry services because of the damage to train and subway infrastructure in New York. (Author's collection.)

Five

EDUCATION
AND RESEARCH

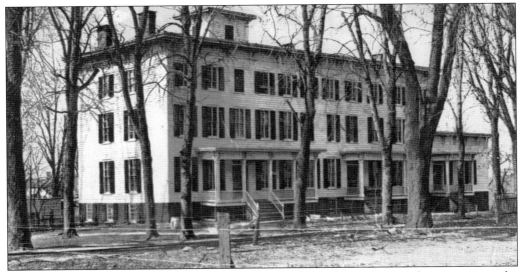

Opened in 1834, Middletown Point Academy operated out of a single-room location across the street from its current location at 10 Church Street in Matawan. In 1857, the current building was erected, with expansions and a name change to Glenwood Institute being completed in 1874. Later, the three-story Italianate-style building housed two other schools: the Collegiate Institute of Middletown Point and the Matawan Military Academy. (Author's collection.)

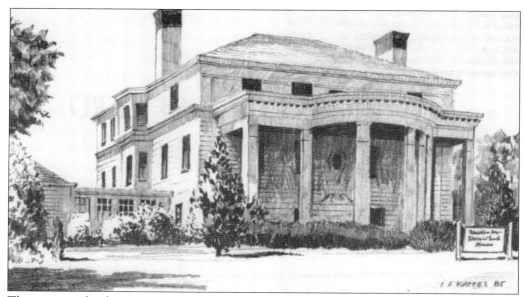

The property that became Croydon Hall Academy was part of the Burdge Farm in the latter part of the 18th century. The original farmhouse was expanded several times in the 19th century and evolved into a beautiful white mansion. Many wealthy New Yorkers came to the area in the 1890s to establish summer homes. The property changed hands and the mansion became the academy in 1946. (Author's collection.)

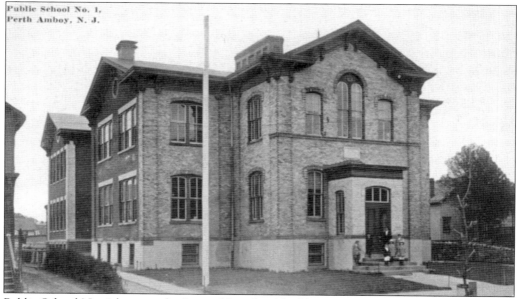

Public School No. 1 became the first public school building in Perth Amboy when it was built in 1871. Originally an eight-room school, the building was doubled in size in 1905. In 1989, the Italianate-style building was renamed in honor of notable African American resident Thomas Mundy Peterson (see page 32). Peterson worked as a custodian at the school from 1871 until 1877. (Author's collection.)

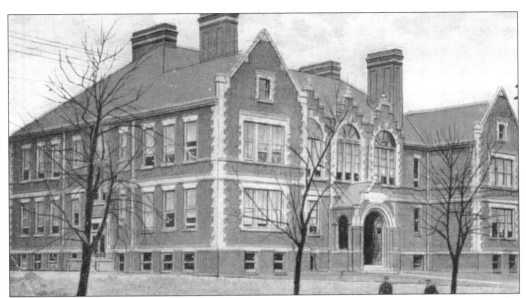

The original Perth Amboy High School (pictured) was built in 1881 and operated until 1971. This building was replaced by the current high school building at 300 Eagle Avenue to accommodate an increase in students in the district. (Author's collection.)

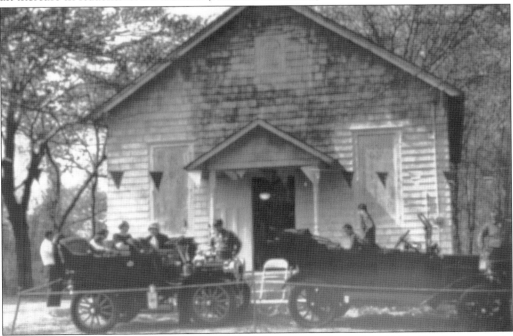

The Madison–Old Bridge Township Historical Society was formed in 1964. Headquartered in a redbrick schoolhouse that was built in 1885, the Thomas Warne Museum houses over 5,000 artifacts, including locally made pottery, Native American objects, farm implements, and colonial items. The unique and original school furniture in the small building, once known as Cedar Grove School, brings back memories of an earlier era of "one-room schoolhouse life." (Madison–Old Bridge Township Historical Society.)

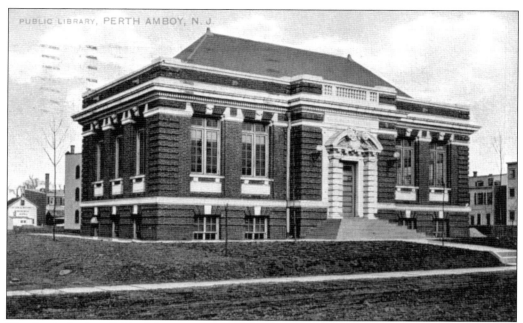

The Perth Amboy Public Library is one of the first library buildings funded by the industrialist Andrew Carnegie in 1901. The goal was to provide a "free library" to enrich the general public. The library opened in 1903 and is still in operation today. The library is one of the oldest continuously operating Carnegie-funded libraries in the country. (Author's collection.)

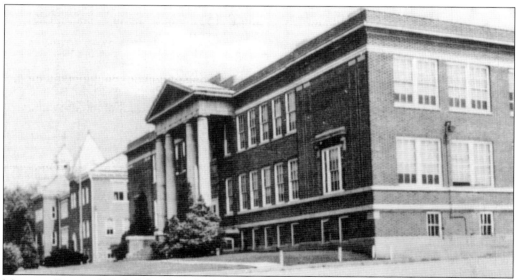

Matawan Regional High School was built next to the expanded grammar school in 1923 to reduce overcrowding in the school district. It offered four courses of study: normal, classical, scientific, and commercial. This landmark building on Broad Street ceased operations as a school in 1962 when a new high school was built on Atlantic Avenue in Aberdeen. In 2000, this building was demolished because it was in danger of collapse. (Author's collection.)

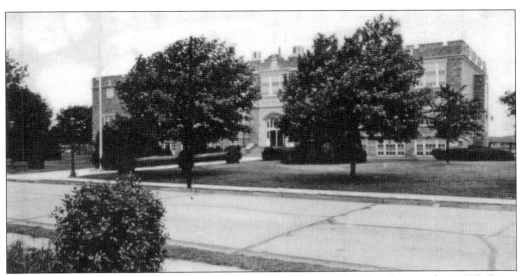

Keyport High School's original three-story structure was completed and opened in 1927. Since then, the school has increased in size, adding several buildings to the campus that serves students from not only Keyport but also nearby Union Beach. Notable Red Raider (the school's mascot) alumni include songwriter and bandleader Moe Jaffe, Wall Street banker Sayra Fischer Lebenthal, New Jersey politician and judge Kenneth Hand, and former professional football placekicker Piotr Czech. (Author's collection.)

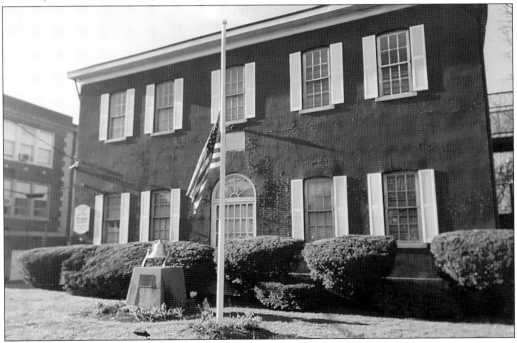

Sayreville New School No. 1 was built in 1885. The brick schoolhouse that educated generations of Sayreville students became the home of the Sayreville Historical Society Museum in 1984. The museum, located at 425 Main Street, houses over 5,000 artifacts that tell the story of the community. (Sayreville Historical Society.)

Sayreville War Memorial High School was founded in 1939. The current location on Washington Road in the Parlin section of the community opened in 1962. Named in honor of the community's World War II veterans, the school has maintained a hall of fame recognizing notable alumni since 2005. The hall of fame honors former Bombers (the school's mascot) who have made notable contributions to their profession, organization, and the community. (Author's collection.)

Born on January 23, 1940, in Perth Amboy, Alan Cheuse became a respected writer, editor, professor, and radio commentator. A 1957 graduate of Perth Amboy High School, Cheuse later studied at Rutgers University, where he earned a doctorate in comparative literature in 1974. He was the author of several novels, collections of short stories, and essays as well as a regular contributor and book commentator for NPR. Cheuse died in 2015. (Author's collection.)

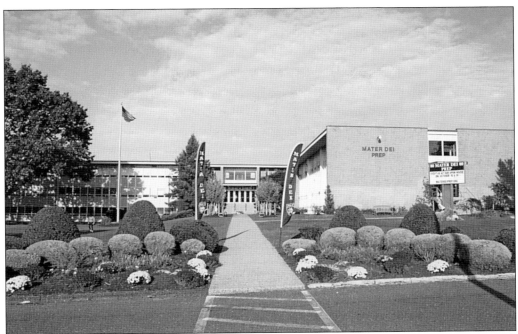

Mater Dei Prep was a four-year Roman Catholic coeducational high school in the New Monmouth section of Middletown Township. Founded in 1961 by Rev. Msgr. Robert T. Bulman, the school enrolled students from Monmouth and Middlesex Counties. Notable alumni include football executive Billy Devaney, political journalist Nick Gillespie, sports journalist Bob Halloran, actor Robert Harper, journalist Brian Williams, and soccer player Richie Williams. (Author's collection.)

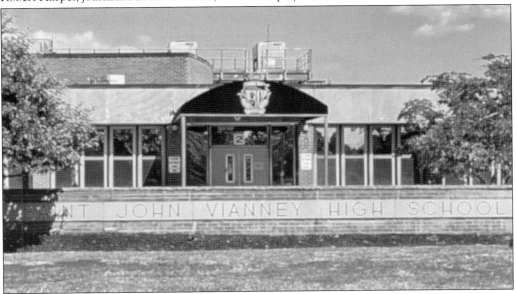

Opened in 1969, Holmdel's St. John Vianney High School educates students from throughout Monmouth, Middlesex, and Ocean Counties and is operated by the Roman Catholic Diocese of Trenton. Many students come from the Bayshore region communities of Holmdel, Hazlet, Aberdeen, Matawan, Old Bridge, and Middletown. (Author's collection.)

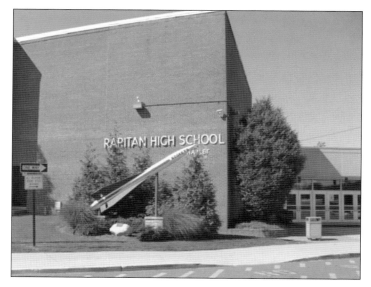

Raritan High School has served Hazlet high school students since 1962. Prior to its opening, students from the town attended Keyport High School under an agreement between the two communities. Located at 419 Middle Road, Raritan High School is named for Raritan Township, the former community name of Hazlet. The Raritan Rockets athletic teams compete in Division A Central of the Shore Conference. (Author's collection.)

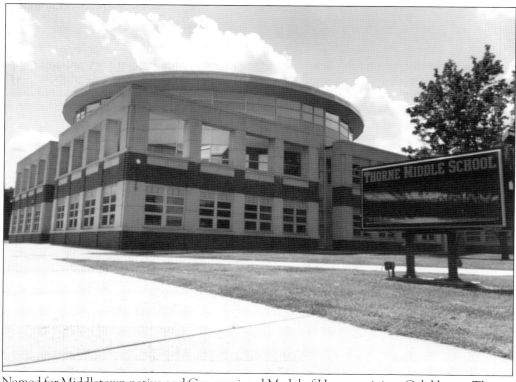

Named for Middletown native and Congressional Medal of Honor recipient Cpl. Horace Thorne (see page 78), Thorne Middle School educates sixth-grade through eighth-grade students. The school was opened in 1962 adjacent to the Thorne family property. Thorne's Congressional Medal of Honor and Purple Heart are on display in the school's main hallway, and students are shown a film, *An American Hero*, to showcase the acts of heroism demonstrated by their school's namesake. (Author's collection.)

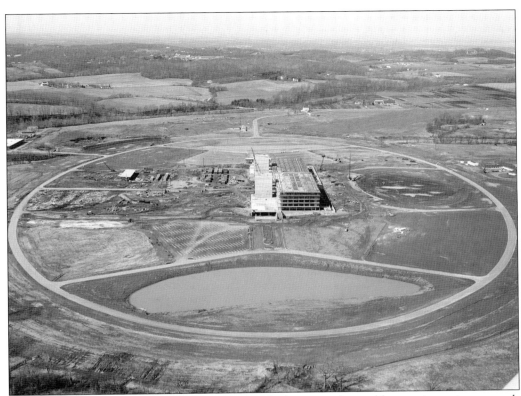

From the late 1940s to the late 1970s, Bell Labs, the largest and arguably most inventive research organization in the world, won numerous high-level awards for innovations. The large, distinctive-looking building was designed by the renowned Finnish architect Eero Saarinen and built between 1959 and 1962. Despite nearly being demolished, the building was renovated and reopened in 2019 as Bell Works, a multiuse facility. (Monmouth County Historical Association.)

Robert Woodrow Wilson (pictured, left) was a radio astronomer from Bell Telephone Laboratories in Holmdel. In 1970, he led a scientific team that made the first detection of a rotational spectral line of carbon monoxide in an astronomical object, the Orion Nebula, and eight other galactic sources. He shared with Arno Penzias the 1978 Nobel Prize in Physics for a discovery that supported the Big Bang model of creation. (Author's collection.)

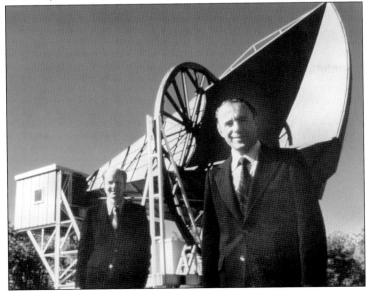

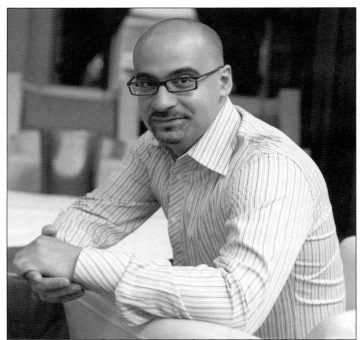

A 1987 graduate of the now defunct Cedar Ridge High School in Old Bridge, Junot Diaz is a novelist, writer, professor, and activist. A recipient of numerous literary awards and a *New York Times* best seller, Diaz teaches creative writing at the Massachusetts Institute of Technology. A Dominican American, many of his literary works focus on the immigrant experience. In 2008, he received the Pulitzer Prize for fiction for his novel *The Brief Wondrous Life of Oscar Wao.* (Author's collection.)

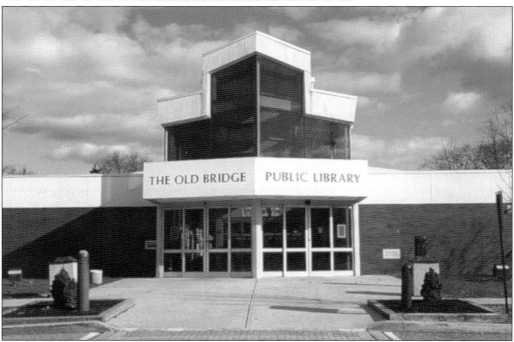

Old Bridge Public Library's origin dates back to 1958, when local citizens formed the Madison Township Public Library Association. Fundraising efforts in 1961 allowed for the original library to be opened and housed in the community's Municipal Complex. In 1991, construction began on the new 43,800-square-foot building (pictured) on a 1.5-acre tract of land across from the Old Bridge Ice Arena. (Author's collection.)

Six

MILITARY AND VETERANS

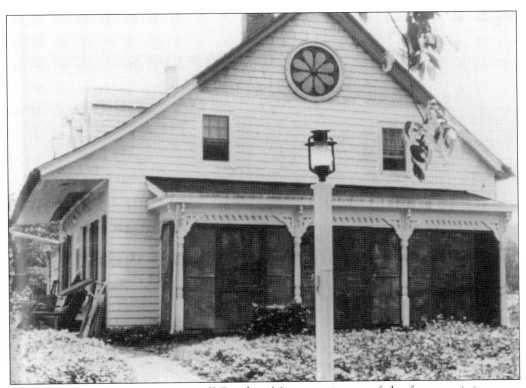

The Hunn-Hawkins House, on Mill Road in Matawan, is one of the few remaining pre–Revolutionary War structures left in the area. Having served as a tavern during the American Revolution, operated by Maj. Thomas Hunn and his wife, Phoebe, it is one of the early houses in the Dutch architectural style in Monmouth County. It served as a meeting place for Major Hunn's Continental soldiers during the conflict. (Author's collection.)

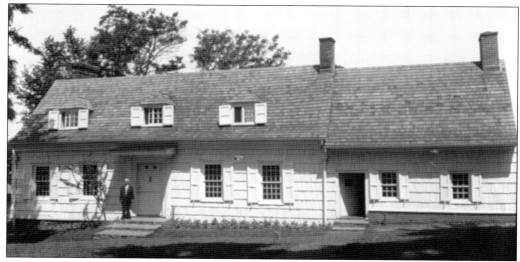

Marlpit Hall, built in the late 17th century and greatly expanded in 1756, was owned by the Taylor family during the American Revolution. Edward and William Taylor were closely associated with the Loyalist cause in Monmouth County. The Middletown area reflected New Jersey's divided loyalties during the conflict. Marlpit Hall was the home of a Loyalist, while the nearby farm of Joseph Murray was home to Patriots. (Library of Congress.)

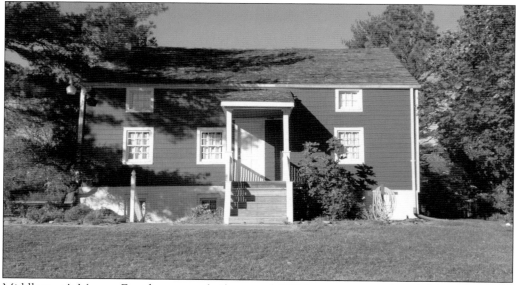

Middletown's Murray Farmhouse was built around 1770 by stonemason Joseph Murray. Murray served in the local Patriot militia, causing his farmhouse to be raided by Loyalists in 1779. In 1780, following his release from prison, Murray resumed his anti-Loyalist activities. Soon after, he was shot in the back and bayoneted while working on his farm. This retaliatory murder is believed to have been carried out by men employed by Edward Taylor. (Author's collection.)

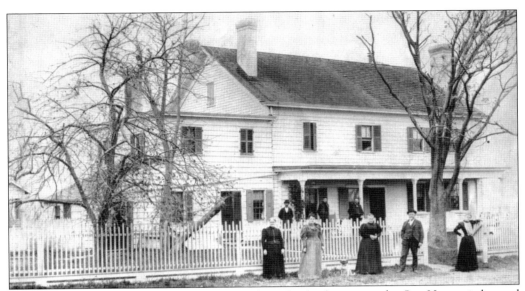

The Seabrook-Wilson House (pictured around 1896), also known as the Spy House, is located in Port Monmouth. Original sections of the residential structure were built in the early 1700s. Legend has it that during the American Revolution, the building was used as a tavern where Patriot sympathizers would gather intelligence by listening to conversations between British soldiers. Although this tale has been debunked by historians, members of the Seabrook family, including father Thomas and son Stephen, were fervent Patriots. (Monmouth County Park System.)

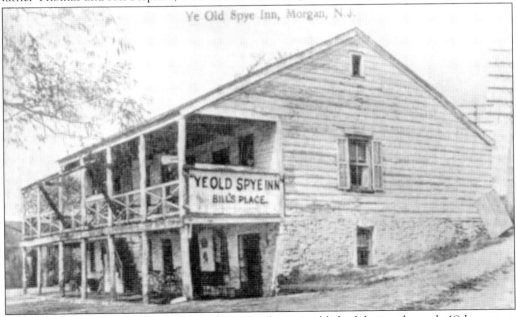

The Morgan Inn (later known as Ye Old Spye Inn) was established during the early 18th century in the present-day Morgan section of Sayreville. According to local lore, the Morgan family was related to the pirate Henry Morgan, who allegedly visited the area. A famous legend associated with the Morgan Inn recounts the execution by hanging of a local Loyalist and British spy, Abe Mussey, on the inn's grounds during the American Revolution. (Sayreville Historical Society.)

Built in 1723 (according to local lore), the Burrowes Mansion, located in Matawan, has served a variety of purposes over its long history including private residence, hotel, and museum. During the American Revolution, the Patriot Burrowes family was the target of a May 27, 1778, raid by Loyalists. During this raid, "Corn King" John Burrowes Sr., a prominent grain merchant, was captured, while his Continental officer son John narrowly escaped. (Library of Congress.)

Samuel Forman was the head of a fervent Patriot family in Middletown Point (now Matawan) during the American Revolution. A colonel in the local Patriot forces and a friend of George Washington, he was the father-in-law to Phillip Freneau. In May 1779, there was a bloody skirmish at the foot of the hill below the house. Patriot wounded were taken to the "old hospital" for treatment. (Author's collection.)

Known as the "Poet of the American Revolution" for his pro-Patriot writings, Middletown Point's Philip Freneau was also a privateer, newspaper publisher, and newspaper editor. His poem "The British Prison Ship" describes the conditions on British prison ships as places where "pain and sorrow dwell." This poem was penned after Freneau was captured with a privateer crew and imprisoned on a prison ship moored in the Hudson River. (Author's collection.)

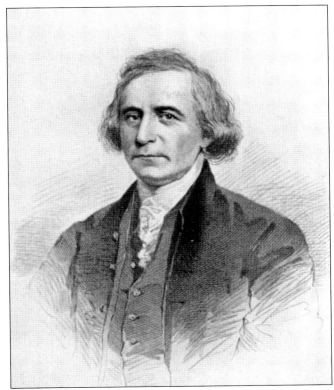

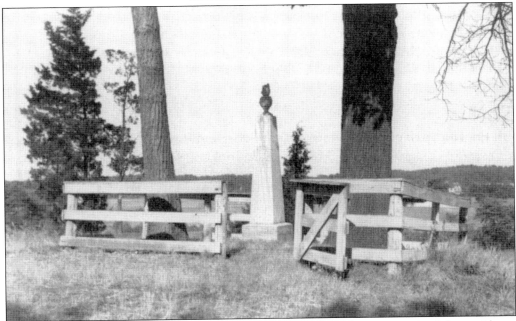

Following the war, Philip Freneau, a close friend of James Madison, became a critic of the presidency of George Washington and a proponent of Jeffersonian policies. He died on December 18, 1832, and is buried on Poet's Drive in Matawan near a former residence. (Author's collection.)

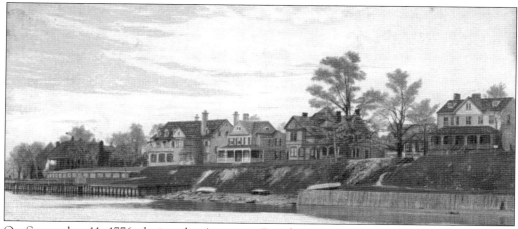

On September 11, 1776, during the American Revolution, Benjamin Franklin, John Adams, and Edward Rutledge were rowed from the Bluff in Perth Amboy to the Billop House in Staten Island for an unsuccessful peace conference with Adm. Richard Howe and Gen. William Howe. On July 22, 1804, Aaron Burr, after mortally wounding Alexander Hamilton, landed at the Bluff seeking help from Thomas Truxton, who helped him escape to Philadelphia. (Author's collection.)

After the June 28, 1778, Battle of Monmouth, withdrawing British Army forces under Sir Henry Clinton (pictured) spread their encampment for about a week along both sides of Old King's Highway in Middletown. They were waiting for transport ships to take them from Sandy Hook to New York. Monmouth was a success for the Continental Army in that it demonstrated that Continentals could fight successfully against British Army regulars. (Author's collection.)

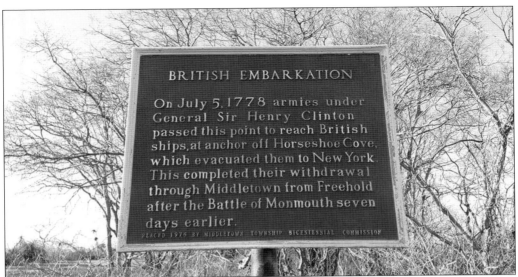

On July 5, 1778, British Army forces under Gen. Sir Henry Clinton evacuated New Jersey via British ships at anchor in Horseshoe Cove. Their destination was British-controlled New York. This completed their withdrawal from Monmouth Courthouse (Freehold) through Middletown after the Battle of Monmouth seven days earlier. This Revolutionary War site is now part of the Sandy Hook unit of the Gateway National Recreation Area. (Author's collection.)

During the American Revolution, Joshua Huddy (pictured being led from prison) was a leader in the Monmouth County militia and a privateer. A fierce adversary of local Loyalists, Huddy was captured in Toms River on March 24, 1782. In retaliation for the death of a Loyalist farmer while in Patriot custody, Huddy was hanged in present-day Highlands on April 12, 1782. The executioners left a note pinned to Huddy's body that ended with, "Up Goes Huddy for Phillip White." (Author's collection.)

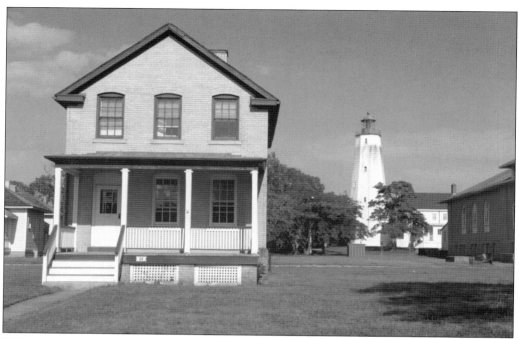

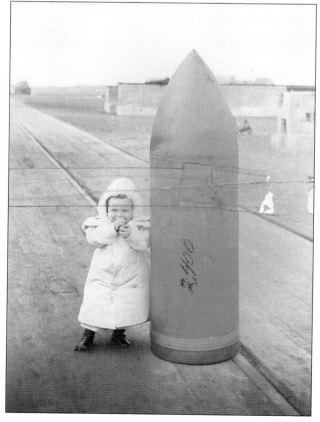

Fort Hancock, built in 1857, is a former US Army fort at Sandy Hook in Middletown Township. The fort, designed by then-captain Robert E. Lee of the US Army Corps of Engineers, served as a coastal artillery base that defended the Atlantic Coast and the entrance to New York Harbor. Fort Hancock was deactivated for coastal gun defenses in 1950 but was reactivated as a Nike missile base until 1974. (Monmouth County Historical Association.)

A daughter of one of the soldiers stands next to a projectile at Fort Hancock around the 1920s–1930s. The 2,400-pound projectile pictured here is for a 16-inch/.50-caliber Model 1919 coastal defense gun. These guns were a key component of coastal defense during this period. A reference to the weight of the projectile appears to be written on the photograph. (Monmouth County Historical Association.)

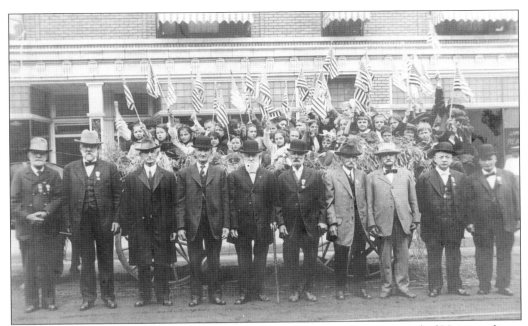

The Grand Army of the Republic (GAR), a fraternal organization composed of Union military veterans of the Civil War, was founded in 1866 in Illinois. Until its dissolution in 1956, the organization was committed to employing powerful political lobbying methods to secure veteran pensions, support Republican candidates, and promote patriotic education. The Bayshore region had GAR posts in several communities, including South Amboy, Perth Amboy, Keyport, Woodbridge, and Atlantic Highlands (pictured). (Monmouth County Historical Association.)

Following World War I, American Legion Post 23 in Keyport was created in 1919, the same year the national American Legion was organized in Paris, France. American Legion Post 23 is the oldest post in Monmouth County. The members of this post have been active in supporting veterans' causes such as suicide prevention, countering homelessness among veterans, and promoting civic education programs. (Monmouth County Historical Association.)

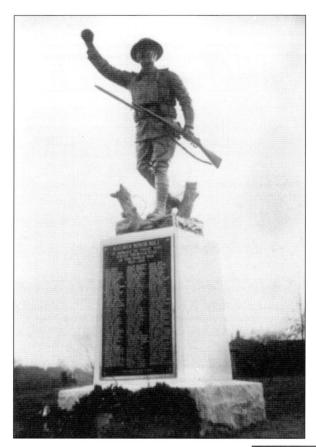

In 1922, the Women's Auxiliary of American Legion Post 176 encouraged the Matawan Borough Council to purchase property near the center of town to become Memorial Park. The auxiliary raised funds to create a statue, *The Spirit of American Doughboy*, by the famous sculptor E.M. Viquesney and dedicated it in 1927 on Armistice Day. Since then, a veterans wall of honor, fireman's monument, 9/11 monument, and 1916 shark attack monument have been added. (Author's collection.)

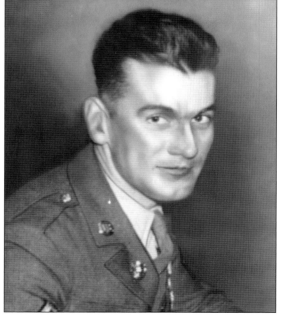

Horace M. Thorne was born on September 29, 1918, in Keansburg and raised in Middletown. Thorne was killed in action after destroying a German tank and while attempting to clear German positions near Grufflingen, Belgium. He was posthumously awarded the Congressional Medal of Honor on September 19, 1945, for his acts of heroism during World War II and is interred at Fair View Cemetery in Middletown. (Author's collection.)

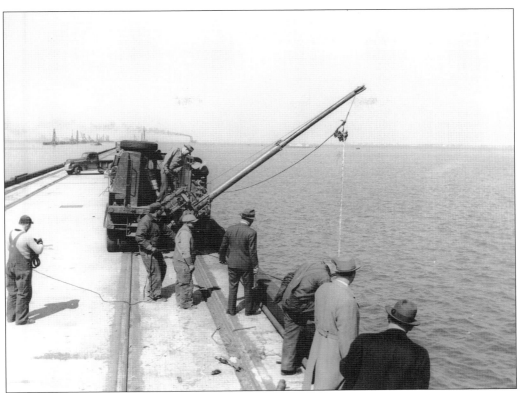

During World War II, the New York Harbor area was a prime target for German U-boat and aircraft attacks. Naval operations required an ammunition depot near the greater New York metropolitan area but away from the heavily populated neighborhoods. Naval Weapons Station Earle became a Navy base in the Sandy Hook Bay area, which includes an almost three-mile-long pier where ammunition can be loaded onto and unloaded from warships. (Monmouth County Historical Association.)

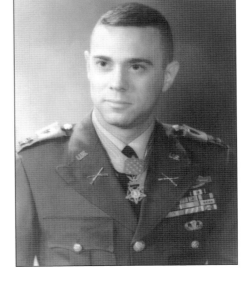

Jack Howard Jacobs was born in Brooklyn on August 2, 1945, moving with his family to Woodbridge Township as a child. There, he graduated from Woodbridge High School in 1962. A graduate of Rutgers University, he entered the Army in 1966. Jacobs was awarded the Congressional Medal of Honor on March 9, 1968, for gallantry while serving in the Kien Phong Province in the Republic of Vietnam. (Author's collection.)

Established in 1998, the New Jersey Vietnam Era Museum & Educational Center is located adjacent to the New Jersey Vietnam Veterans Memorial in Holmdel. Housed in a 5,000-square-foot facility, the museum and educational center was established with the mission of providing a balanced view of the often controversial war in Vietnam. (Author's collection.)

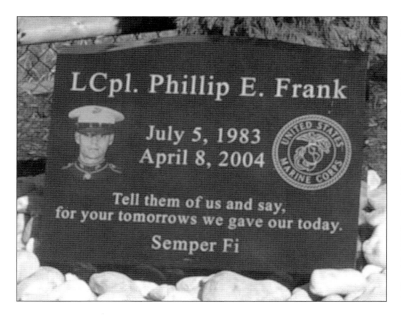

Phillip E. Frank was born on July 5, 1983, in Cliffwood Beach. A 2002 graduate of Matawan Regional High School, Frank was inspired to enlist in the Marine Corps after the September 11, 2001, terrorist attacks. Frank was killed on April 8, 2004, by hostile fire in the Anbar Province during Operation Iraqi Freedom. LCpl. Phillip E. Frank Way in Cliffwood was named in his honor in 2012. (Author's collection.)

Seven

TO SERVE AND PROTECT

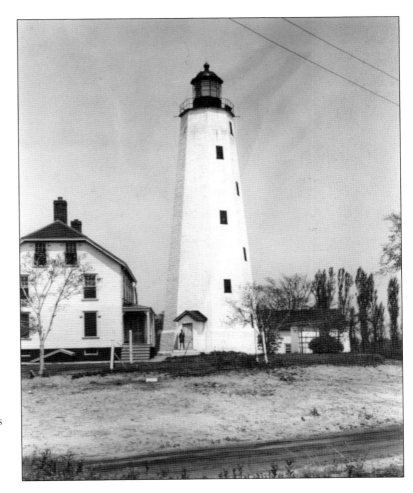

Fort Hancock, no longer an active Army installation, is now part of the National Park System. The Sandy Hook Lighthouse, built in 1764, is the oldest continuously operated lighthouse in the United States and is located on the grounds of Fort Hancock. (Library of Congress.)

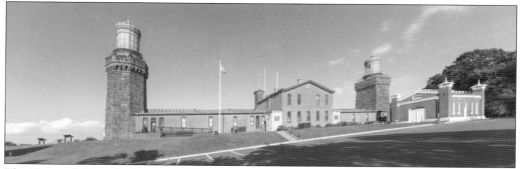

The Navesink Twin Lights in Highlands, listed on the US National Register of Historic Places, is one of the greatest historic landmarks on Monmouth County's Bayshore. It was originally a pair of wooden lighthouses built in 1828. The present brownstone structure, built in 1862, was designed by Joseph Lederle. It consists of two towers, one octagonal and the other rectangular, along with the keepers' area and storage facilities. (Library of Congress.)

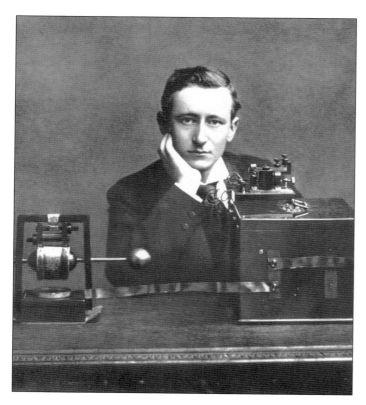

The Navesink Twin Lights were the first to use the powerful Fresnel lens, a French innovation with a beam visible for 22 miles. Twin Lights was also one of the first electrified lighthouses with its own generator plant. This historic location hosted the first successful demonstration of the wireless telegraph by Guglielmo Marconi (pictured) in 1899 and the testing of early radar devices. (Smithsonian Institution.)

Constructed in 1880, Great Beds Light has become a symbol of South Amboy over its history. This sparkplug lighthouse became unmanned in 1945, when the Fresnel lens was replaced with an electric beacon. In January 1918, the Raritan Bay froze over, and people walked approximately one mile out to the lighthouse from the South Amboy shore (pictured). (Author's collection.)

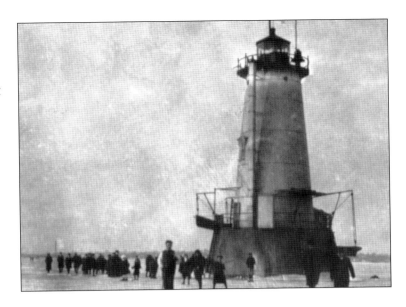

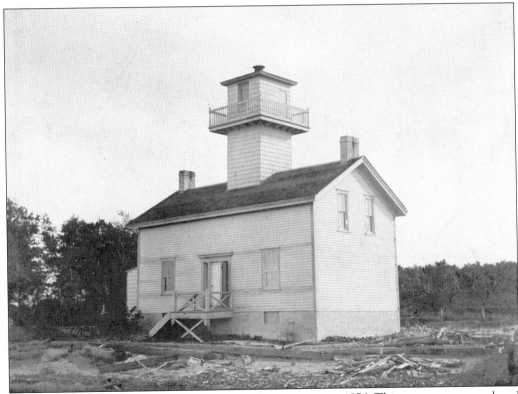

Keansburg's Bayside Beacon was built as a wooden structure in 1856. This structure was replaced by a 45-foot metal tower in 1919. The original wooden structure was repurposed as the lightkeeper's home and, later, a restaurant before being destroyed by fire in the early 1950s. The original structure is pictured here around 1906. (Monmouth County Historical Association.)

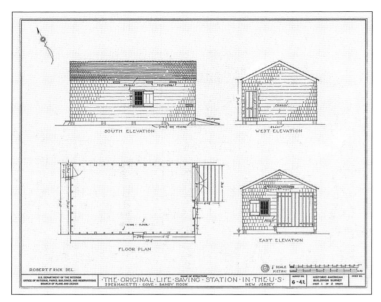

In 1878, Congress established the US Life-Saving Service and began assigning six-member crews to sites in New Jersey. There were two life-saving stations on Sandy Hook. One was near the tip of "the Hook," while the other was near Spermaceti Cove. The rescue equipment included a surfboat mounted on a wagon, a line-throwing mortar, and a small metal lifeboat (life car) that held up to six passengers. (Library of Congress.)

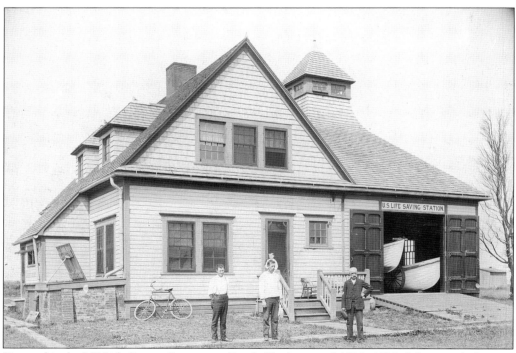

Pictured is the US Life Saving Station on Sandy Hook around 1900–1903. (Monmouth County Historical Association.)

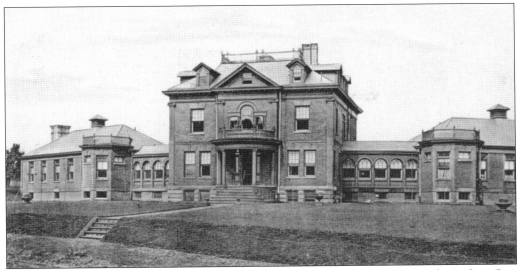

The origin of Raritan Bay Medical Center dates back to 1902, when the Perth Amboy City Hospital (pictured) opened with 12 beds and six doctors. This large comprehensive health-care center includes nine community hospitals and is the leading nonprofit health-care organization in the state. The Raritan Bay region segment of this organization includes centers in Perth Amboy, Old Bridge, and Holmdel. (Author's collection.)

Hazlet Fire Company No. 1 was incorporated in 1910. The fire company is pictured here preparing for a parade in Keyport in 1928. (Author's collection.)

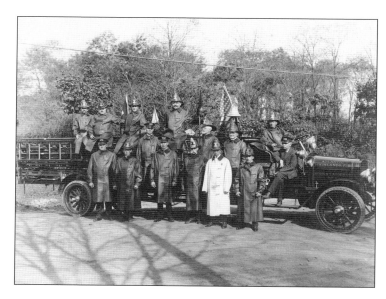

Everett Hook & Ladder Company No. 1 was formed in 1882, changing its name to Atlantic Highlands Hook & Ladder Company No. 1 in 1885. The fire company is pictured here around 1918–1920. (Monmouth County Historical Association.)

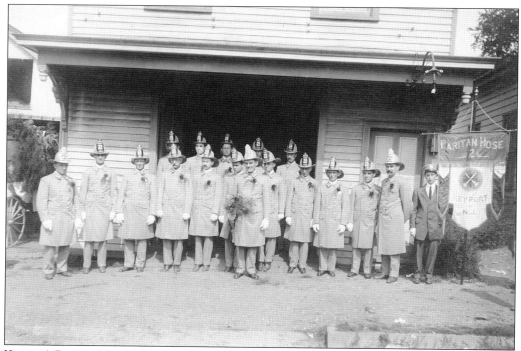

Keyport's Raritan Hose Company No. 2 was founded in 1893. The fire company's station (pictured) was located at 86 Broad Street, a building currently occupied by the Keyport Fire Museum. (Monmouth County Historical Association.)

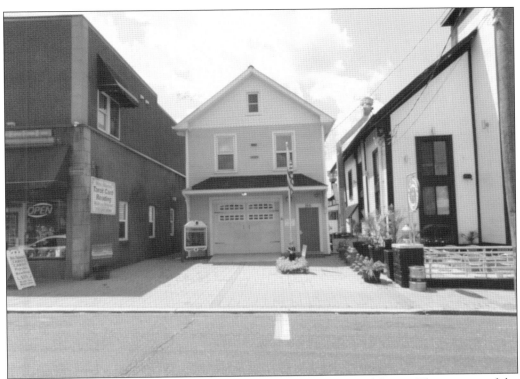

The Keyport Fire Museum and Education Center is located on Broad Street. The purpose of the museum is to inform the public on fire history, promote volunteerism, and educate the public on fire prevention. The museum contains displays of vintage firefighting gear and fire hydrants. (Keyport Fire Museum.)

When the massive German dirigible *Hindenburg* caught on fire and crashed at the Lakehurst Naval Air Station in May 1937, several Bayshore-area fire companies responded to help at the accident scene. The Keyport Fire Museum has considerable information and artifacts, including a piece of the *Hindenburg*, associated with this historic New Jersey tragedy. (Author's collection.)

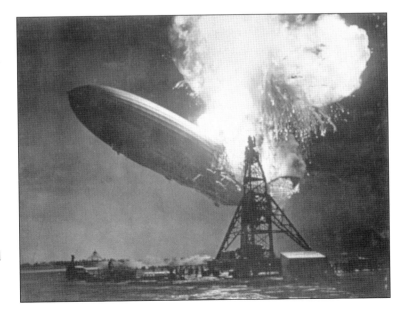

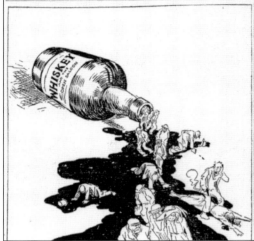

House Adopts Prohibition Amendment by 282 to 128

Measure Goes to Conference—Period for Ratification Is Only Difference

Parties Evenly Divided on Vote

141 Democrats and 137 Republicans Join Independents to Vote "Yes"

WASHINGTON, Dec. 17—Nationwide prohibition won in the House today, and only the adjustment of a slight difference in resolutions between the House and Senate now stands in the way of submitting to state legislatures an amendment to the Federal Constitution forbidding the manufacture, sale or importation of intoxicating liquor for beverage purposes in the United States or its territories.

The vote in the House, taken after a day of debate before crowded galleries, was 282 to 128, with the parties dividing almost evenly.

The margin for prohibition was just right votes more than the necessary two-thirds of the membership of the House required for adoption and twenty-six more than two-thirds of those voting.

Along the Raritan Bayshore region, the national Prohibition experience (1920–1933) brought a mixed response among residents. Some vigorously supported the Prohibition movement on moralistic grounds, while others wanted to keep the liquor flowing. Coastal towns in the region, such as Atlantic Highlands, became popular vacation spots for middle- and upper-class New Yorkers, some of whom demanded access to liquor. (Author's collection.)

Rumrunners often employed high-speed boats to deliver illicit alcohol to underworld contacts on shore. Hijackers, seeking to get a cut of this trade, were prepared to ambush those transporting and delivering alcohol. During Prohibition, it was not uncommon for gunfights to erupt between law enforcement and criminals in the region. A number of local politicians and police officers were also tempted to turn a blind eye to the illicit trade. (Author's collection.)

RUM CRAFT AGAIN LAND CARGOES AT HIGHLANDS

Eight Come Ashore After Enforced Holiday Since Friday Large, Speedy, Unnamed Vessel Among Them—Reports of Last Week's Traffic Called Overdrawn.

Staff Correspondence.

HIGHLANDS, Jan. 17.—Rum-running craft were bringing liquor to shore last night for the first time since Friday, when a holiday was declared as the result of publicity focusing federal attention on this resort.

According to men well informed on the activities of the smuggling craft eight of them rode into port with cargoes before 9 o'clock last night. Four others declared to be on a similar mission went out to sea last night, but so far as can be learned have not returned. Each vessel of the size ordinarily engaged in the traffic carries about 250 cases.

A big boat, bearing no name, was among those mentioned as having run liquor last night. The craft is much larger than the usual smuggler. It was tied up today. Its ownership seems to be unknown even to those who profess to know the workings of the bootleggers.

What is unknown about the ownership is, however, made up for by the knowledge Highlanders generally declare they have of its abilities. It contains two aeroplane motors and is credited with being able to do thirty-five miles an hour. When the uninformed seem unwilling to accept the statement of its speed as capable of twenty-five miles an hour.

While practically every one in Highlands concedes that rum smuggling here and at nearby points is actual, the general declaration is that Associated Press reports of operations Thursday night were greatly overdrawn.

In the first place, they declare that the vessels in this section capable of engaging in the running are not numerous enough to land 35,000 cases a night, as those reports declared was done. But even if that were possible they say that the number of vehicles necessary to cart the cargoes away would so great that the operation would arouse the entire community even if the number of trucks and touring cars necessary were available.

A man whose home commands a good view of the bay at Sandy Hook, and who says that he frequently use powerful glasses to scan the bay, declares that Thursday's operations were not on a huge scale. He said that to have carried the reported cargoes of 35,000 cases there would have been required a constant stream to and from of the little craft, and that he would have seen them.

The mother ships, which bring the liquor supplies for the runners to a point outside the three-mile limit, are said to be standing twelve miles off shore. A series of reasons are given for their being so far beyond the limit. One is that the recent storm struck fear into the hearts of their captains that they would be driven inside the limit, where their capture would be possible, or possibly blown ashore and wrecked. Another is the complaints of legitimate shipping that their presence near shore without lights is a menace.

To get to the mother ships it is necessary for the runners to pass around Sandy Hook and to return by the same route. This fact makes it appear to be an easy task to catch the smugglers. But it is conceded that it is not easy for the reason that the smugglers knowing that they are pursued, quickly throw their cargoes overboard, and then if they are overtaken by federal craft nothing can be done because of the absence of evidence.

On February 25, 1926, the Borough of Matawan passed a municipal ordinance establishing a formal police department. Prior to this, police protection was provided by appointed town marshals. The new police organization became active with the appointment of Edwin Sloat to the rank of chief of police. Matawan Police officers are pictured here in about 1941. (Monmouth County Historical Association.)

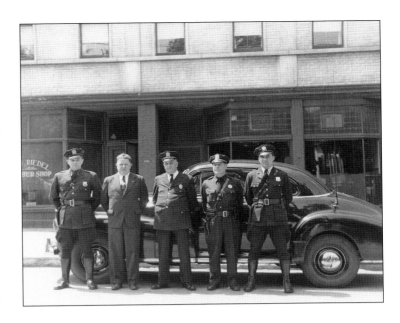

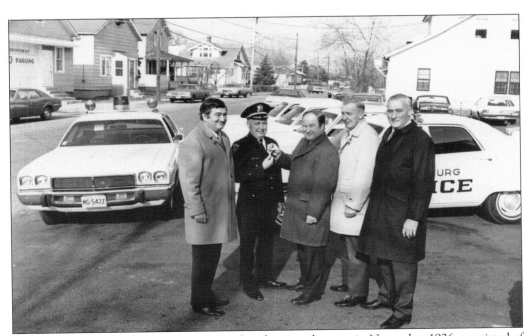

The Keansburg Police Department, created under an ordinance in November 1926, consisted of five members. Prior to 1926, Keansburg was under the authority of a police marshal. Pictured here are Keansburg Police officers with new police cars in 1975. (Randall Gabrielan.)

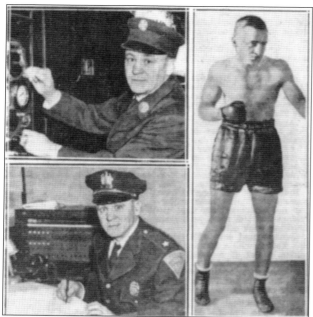

Keansburg's Teddy Loder was a professional boxer who fought between 1931 and 1938, amassing a record of 47 wins, 10 losses, and 9 draws. Loder's final fight took place at Balbach's Auditorium in Keansburg. Following his boxing career, Loder embarked on a career in law enforcement, joining the Keansburg Police Department in 1943. He retired as a deputy chief in 1975 and is interred in Fair View Cemetery in Middletown. (Keansburg Historical Society.)

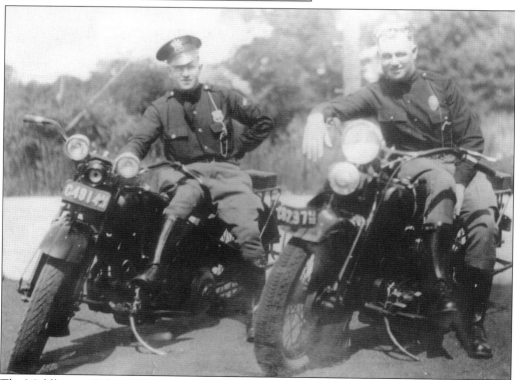

The Middletown Police Department was established on May 15, 1928. The department's first full-time police officer was Earl N. Hoyer, who was appointed a patrolman and chief of police. This c. 1933 photograph shows William Fix (left) and Chief Hoyer (right) in uniform on motorcycles. (Randall Gabrielan.)

Joseph M. McCarthy's long career in law enforcement began in 1954 when he was hired as a patrolman by the Middletown Police Department. A native of Middletown, McCarthy served in the Army during World War II. On July 12, 1967, he was promoted to the rank of chief of police in the department, a position he served in for 23 years. (Randall Gabrielan.)

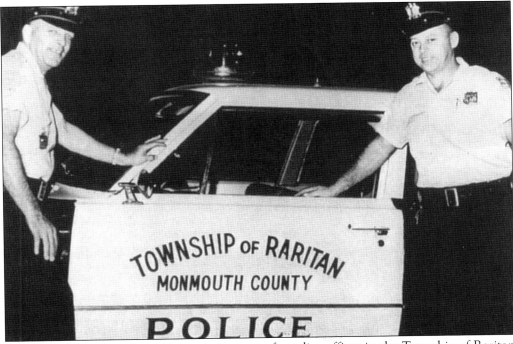

Records indicate that the earliest appointment of a police officer in the Township of Raritan (present-day Hazlet) took place in 1928. Eugene W. Smith patrolled the community during the summer months. As the township's population increased, so did the need for additional police officers. In 1965, an ordinance was passed establishing a full-time police department. Pictured here are two officers with their squad car around this time. (Author's collection.)

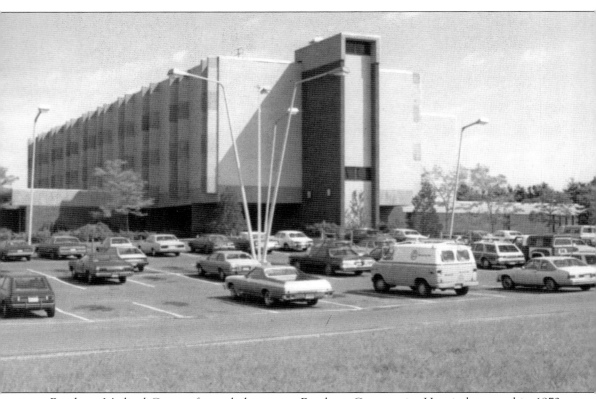

Bayshore Medical Center, formerly known as Bayshore Community Hospital, opened in 1972 on a 17-acre parcel of land on North Beers Street in Holmdel. The hospital originally had 158 acute-care beds but, over time, expanded to a 169-bed general medical and surgical hospital. The award-winning medical center serves as a critical component of the health-care infrastructure of the Raritan Bayshore region and provides a number of medical services. (Author's collection.)

Eight

RELIGIOUS INSTITUTIONS

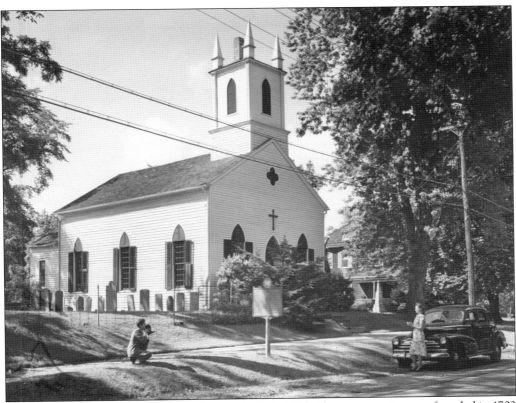

Christ Church in Middletown Township was built in 1744. The congregation was founded in 1702 but met in private homes for several years. In 1736, William Leeds, a reported cohort of the pirate Capt. William Kidd, left a large piece of land for the church, with a sizeable trust of money and property to be distributed after his death. In 1738, King George II granted the church an official charter. (Monmouth County Historical Association.)

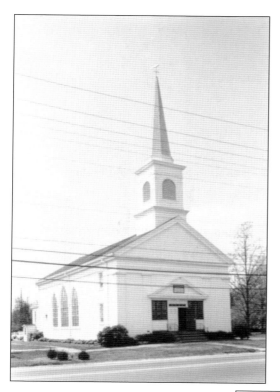

Upper Meeting House of the Baptist Church of Middletown was built in 1809 in Holmdel, with considerable remodeling undertaken in the late 19th century. Founded in 1688 by Baptists from Rhode Island, this was the first congregation of its kind in New Jersey. The original building on this site was completed in 1705 and laid the foundation for future religious communities to utilize this site. (Monmouth County Park System.)

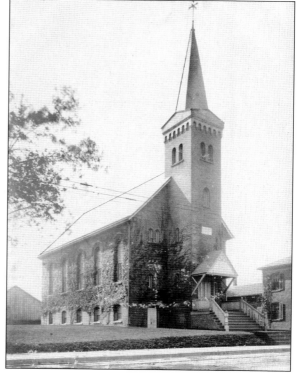

The Sayreville United Methodist Church, chartered in 1848, became the first religious community in the section of South Amboy that became Sayreville in 1876. This Methodist community came to the area through a circuit rider who established a stop at the Roundabout section of South Amboy. Peter Fisher, cofounder of the Sayre & Fisher Brick Company, donated funds and supplies for the 1869 construction of the 33-by-43-foot church. (Author's collection.)

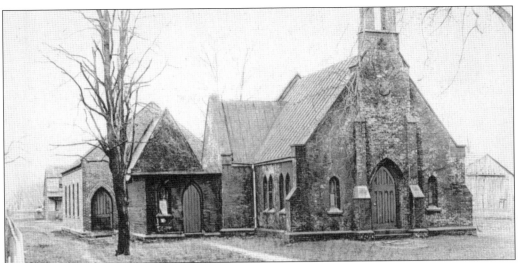

Matawan's Trinity Episcopal Church congregation was founded in 1850, with the building on Main Street completed in 1851. The small congregation obtained full parish status in 1958. As a result of the increased population in Matawan in the late 1950s and early 1960s, the congregation outgrew the small building and moved to another part of town in the late 1960s. The original building became home to restaurants. (Author's collection.)

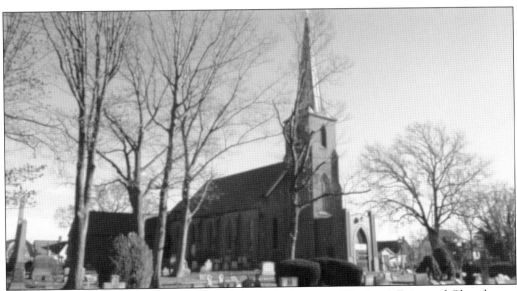

Although the current building dates back to 1852, the history of St. Peter's Episcopal Church goes back to the 17th century. New Jersey's oldest Episcopal parish held its first service in 1685 and received a royal charter in 1718. During the American Revolution, Patriot forces in Perth Amboy exchanged cannon fire with British forces across the Arthur Kill that damaged the church and tombstones in the cemetery. (Author's collection.)

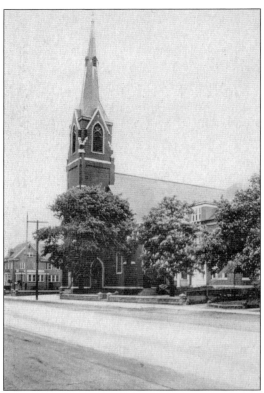

St. Joseph Roman Catholic Church dates back to 1854, when, despite anti-Catholic sentiment in the area, the first building was constructed on Main Street in Keyport. A second building was constructed on the same spot in 1879, eventually being demolished in 1973. A new church (pictured here) was built at the same location as its predecessors, with the first mass being said on December 8, 1976. (Author's collection.)

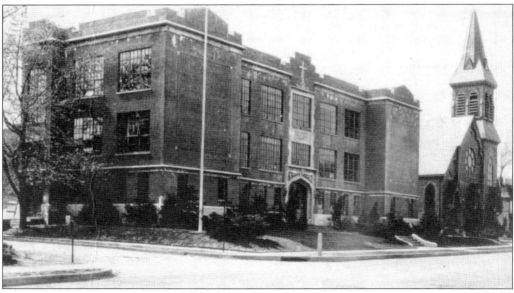

Located near Grove Street and Amboy Avenue in Woodbridge, St. James Roman Catholic Church dates back to 1860, when a community of Catholics gathered to celebrate mass in local households. Over the years, several structures were built to host services, leading up to the current church's construction and dedication in 1968. The new church (pictured) was built of Pennsylvania limestone in the Neo-Romanesque style and can seat over 1,000 parishioners. (Author's collection.)

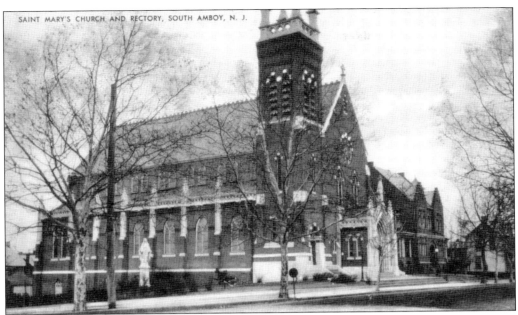

SAINT MARY'S CHURCH AND RECTORY, SOUTH AMBOY, N. J.

Construction on St. Mary's Roman Catholic Church in South Amboy was completed in 1876 at a cost of approximately $80,000. Construction and masonry work on the church building was supported by parishioners, many of whom worked as laborers, in their spare time. The church was built for the parish that was originally established as part of a mission field that extended along the Jersey Shore in 1851. (Author's collection.)

St. Catharine's Church was built in 1879 on a one-quarter-acre plot donated by Thomas Meehan on Stilwell Road in Holmdel. The pews inside the church could seat around 100 parishioners, many of whom came from the nearby burgeoning Irish Catholic population. In 1975, the Archdiocese of Trenton donated the church and property to the Holmdel Historical Society for one dollar. Pictured here is the church's altar. (Holmdel Historical Society.)

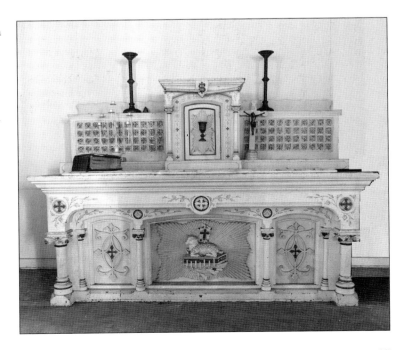

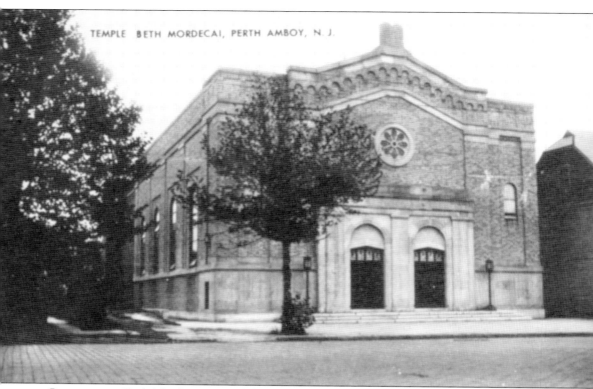

TEMPLE BETH MORDECAI, PERTH AMBOY, N. J.

Congregation Beth Mordecai opened the doors of its building on High Street near the marina in Perth Amboy in 1926. Founded in 1897, the congregation's roots go back to the First Perth Amboy Hebrew Mutual Aid Society (established around 1891). Henry Wolff, born in East Prussia in 1845, was one of the founding fathers of this congregation, which, at the time, was largely made up of German and Hungarian immigrants. (Author's collection.)

The Presbyterian faith in Matawan traces its roots back to late-17th-century Scottish settlers in the area. The original First Presbyterian Church (pictured here) was built on Main Street in 1841 and served the community until it was destroyed by fire on Christmas Night in 1955. The original church building was popular amongst locals for its Stanford White–designed steeple. (Author's collection.)

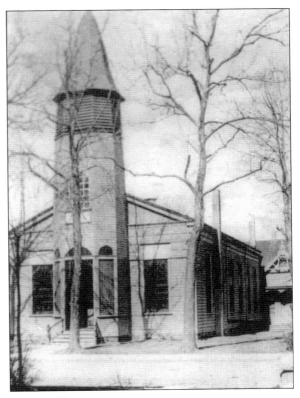

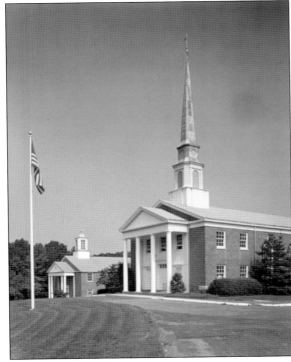

Following this tragic event, a new First Presbyterian Church building (pictured here) was opened in 1959 near Franklin Street and Route 34 in Matawan. The church runs a number of community programs, including the Presbyterian Nursery School, founded in 1967. (Library of Congress.)

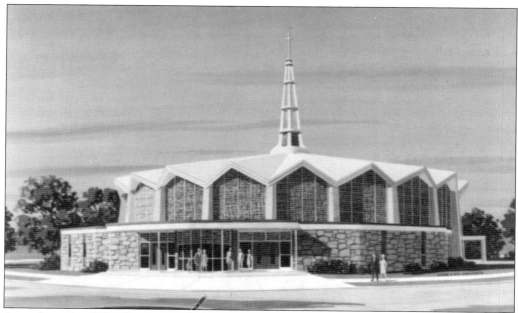

As early as the 1850s, Roman Catholic services were celebrated in Middletown Point (present-day Matawan). These early Catholics were often harassed and opposed by members of the Ku Klux Klan in the area. Founded in 1965, St. Clement's was established by the bishop of Trenton, George W. Ahr, to serve the growing population in Matawan. Many members of the early clergy came from nearby St. Joseph's in Keyport. (Author's collection.)

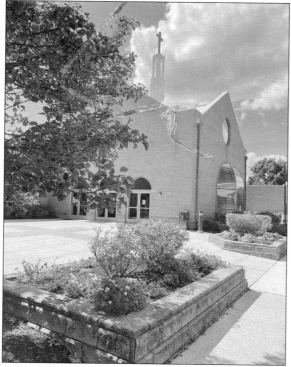

On April 12, 1961, Fr. Edward P. Blaska broke ground on a 25-acre plot of land in Holmdel that would serve as the Roman Catholic Community of St. Benedict. The grand opening was celebrated with a dedication ceremony overseen by Bishop George W. Ahr of the Diocese of Trenton on September 22, 1962. The first class of students graduated from its school in June 1968. (Author's collection.)

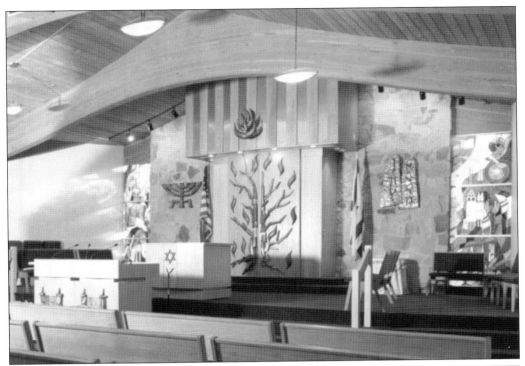

Temple Shalom, founded in 1963, is a Reform Jewish congregation in Aberdeen that serves the local communities of Monmouth and Middlesex Counties. Doug Emhoff, husband of Vice Pres. Kamala Harris, was a member of Temple Shalom during his childhood. (Temple Shalom.)

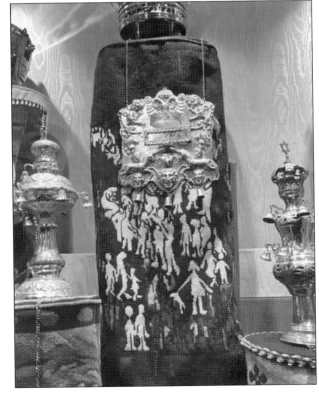

Temple Shalom houses Czech Memorial Torah Scroll No. 1103, which is estimated to be more than 120 years old. The Torah originated in a synagogue in Pardubice (present-day Czech Republic) that was closed by the Nazis in 1942. Having survived Nazi pillaging, the Torah was donated in 1967 by the Bergenfield family. (Temple Shalom.)

Middletown's Islamic Society of Monmouth County and Al-Aman Mosque have served the local Muslim community since 1986. In addition to providing a place of worship, the organization and associated mosque provide a number of social, educational, and economic services to the community. Since its inception, members of the community have been active in a number of humanitarian relief and development organizations that respond to domestic and international emergency and disaster situations. (Islamic Society of Monmouth County.)

Nine

TRAGEDY, DEATH, AND REMEMBRANCE

This Matawan cemetery was established in 1763 as part of the Mount Pleasant Presbyterian Church. An opponent of the British, Rev. Charles McKnight allowed Patriot meetings at the church during the American Revolution. In 1777, a British raiding party captured him at the church and imprisoned him on a prison ship in New York Harbor. Released in 1778, McKnight died from complications from his imprisonment. Over 400 burials took place at this cemetery. (Author's collection.)

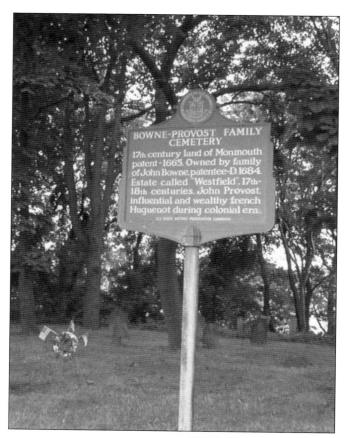

The Bowne-Provost Family Cemetery is a small cemetery in Laurence Harbor with a unique historic past. The land was given to John Bowne, the patentee, in the British Monmouth Patent of 1665. The estate was later called Westfield in the 17th and 18th centuries. John Provost, a wealthy and influential French Huguenot, acquired the land during the Colonial Era. (Author's collection.)

St. James AME Zion Church is an African American congregation organized in 1843. The area behind the church was designated as a cemetery in 1847. Four Civil War veterans from the US Colored Troops are buried in the cemetery. In the 20th century, the cemetery was abandoned and taken over by the Matawan Historic Sites Commission, leading to a rededication ceremony with a new monument honoring those buried there. (Author's collection.)

Cedar View Cemetery in Middletown was established on November 4, 1850, when a local white farmer, John B. Crawford, sold a two-acre plot of land to 14 free black men. Since then, over 200 people were interred here, including former slaves and US Colored Troops who fought in the Civil War. A historical marker was dedicated by descendants and members of the community in 2022 (pictured). (Middletown Township.)

James P. Donnelly was a surgery student in New York when he took a summer job at the Sea View House hotel in Highlands. Donnelly lost a guest's money gambling with bartender Albert Moses. The following dawn, Moses, stabbed in the neck, named Donnelly as his attacker before dying. Prior to his execution on January 8, 1858, Donnelly escaped imprisonment before being captured trying to reach Keyport, where a fast boat awaited him. (Monmouth County Historical Association.)

Opened in 1858, Rose Hill Cemetery is located at the highest point in Matawan, overlooking the Raritan Bay. Originally known as Fox Hill, it is believed to stand on a Matovancon Native American burial ground. Fox Hill was used by both Patriot and Loyalist spies during the American Revolution. Lester Stillwell and Stanley Fisher from the 1916 shark attacks are buried at Rose Hill. (Author's collection.)

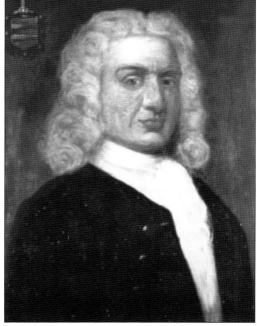

In the late 17th century, Capt. William Kidd served as an English privateer before becoming disillusioned with this arrangement and turning to piracy. According to legend, he buried treasure along Raritan Bay. Kidd's Rangers was a name given to two large Spanish elm trees in Matawan, one on Fox Hill (Rose Hill Cemetery) and the other at the mouth of Matawan Creek. Captain Kidd would allegedly use these landmarks to guide him to his treasure. (Author's collection.)

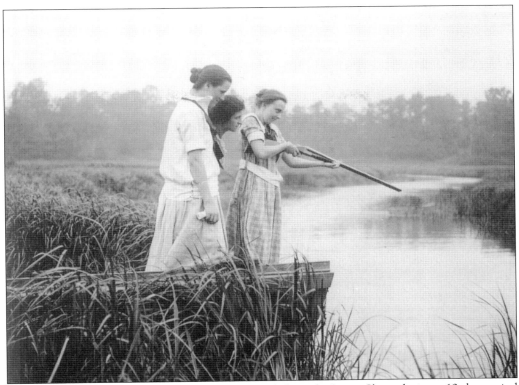

Inspiration for the novel and movie *Jaws* happened along the Jersey Shore during a 12-day period in July 1916. Two fatal shark attacks occurred in Beach Haven and Spring Lake leading up to the July 12 attacks in Matawan's tidal creek. Lester Stillwell, age 11, and his rescuer, Stanley Fisher, age 24, died after being attacked by the same shark. Later that day, Joseph Dunn, age 12, survived his attack with severe wounds. Matawan residents (pictured) mobilized to hunt down the man-eating shark. (Author's collection.)

Near the end of World War I, there was a horrible series of explosions at the T.A. Gillespie Shell Loading Plant (sometimes called the Morgan Munitions Depot) in the Morgan section of Sayreville. Beginning on October 4, 1918, explosions led to the deaths of approximately 100 people. Despite speculation that this tragedy was the result of German sabotage, the official cause was determined to be related to worker error. Pictured here is a man standing in a large crater caused by one of the explosions. (Randall Gabrielan.)

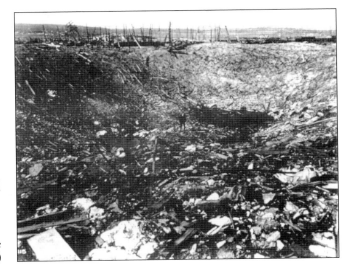

CROWD TORTURES ALLEGED FIREBUG.

Man Suspended Twice at Matawan, N. J., Declares He Is Innocent.

Charles Herbert had a hearing at the Town Hall in Matawan, N. J. to-day. He was arrested in connection with the fire which startled the town last night and which bore evidence of being an incendiary fire.

The blaze started in apartments of Herbert's mother. It caused a general stampede from all the churches. Every resident was on the street.

After the fire had been extinguished an examination of the burning stairway revealed that it had first been soaked with kerosene. Then the citizens in excited groups demanded vengeance. They began a little detective work. Charles Herbert, who is the father of a family and lives on the outskirts of the town, was sought out by a vigilance committee, who dragged him to a barn where a pair of plough lines were procured, and, with cries of "Lynch him!" and "String him up!" and "Hang the firebug!" the noose was put about the man's neck and he was suspended from the floor. He was let down and allowed to make a statement.

"I am innocent," said Herbert.

Again he was jerked from the floor and suspended three feet in the air. After he had been badly strangled he was again lowered and still stoutly maintained his innocence.

With that Herbert was taken to the Town Hall, while an excited crowd followed, crying for the man's blood. He was taken before the Mayor of the town, where he was committed to the town jail until noon to-day. As he was escorted to the jail many citizens kicked and struck at the man in their anger.

The circumstantial evidence is strong against the man, but there is no direct proof of his guilt.

Matawan was visited on Jan. 27 last by an incendiary fire which swept the main business portion of the town, and the fact that firebugs are still at work has greatly alarmed the residents.

The Matawan Fire of 1901, allegedly set by an arsonist, started in or near a harness shop on Main Street on January 27. Due to heavy winds, fire spread through the business district and surrounding area, destroying commercial and residential spaces. A change in the direction of the wind saved the rest of the town. As a result, new fire companies were added to the town. (The *Evening World*.)

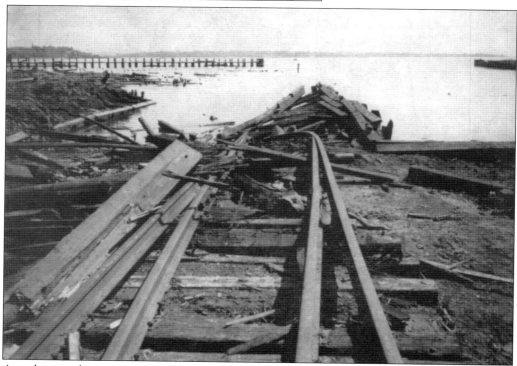

A violent explosion occurred around 7:26 p.m. on Friday, May 19, 1950, at the Pennsylvania Railroad Pier No. 4 (Powder Pier) at the foot of Augusta Street in South Amboy. This explosion was caused by the detonation of two shipments (450 tons) of military munitions—one of land mines and one of dynamite—being transferred from railroad cars onto barges for loading onto the steamship *Flying Clipper*. Thirty-one people were killed. (Rutgers University Libraries.)

On February 6, 1951, at 5:43 p.m., a Pennsylvania Railroad train known as "The Broker" derailed on a temporary wooden trestle in Woodbridge. Over 80 passengers were killed. It remains New Jersey's deadliest train wreck. The train was traveling between 40 and 50 miles per hour when it reached the curve approaching the trestle. The massive locomotive and eight of the eleven cars derailed, hurtling passengers down a steep embankment. (Collection of Gordon Bond, used with permission.)

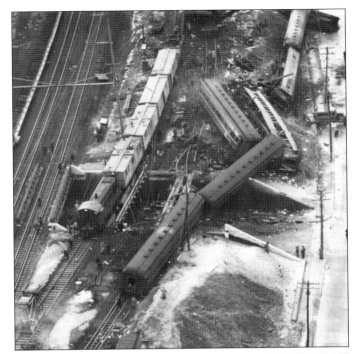

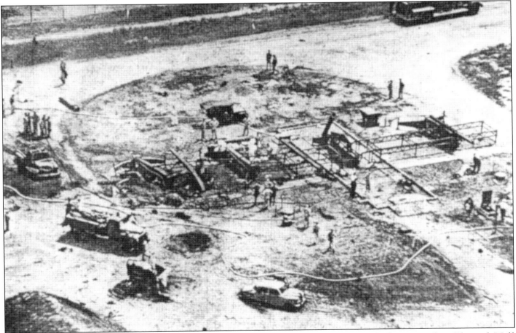

On May 22, 1958, eight missiles blew up at the US Army Nike missile base in the Chapel Hill section of Middletown, killing 10 men. During the Cold War, these anti-aircraft missile bases were established to counter the threat of air attacks by long-range Soviet bombers. Other Nike missile bases in the region were located in Old Bridge and Holmdel-Hazlet. Military operations ceased at this site in 1963. (Randall Gabrielan.)

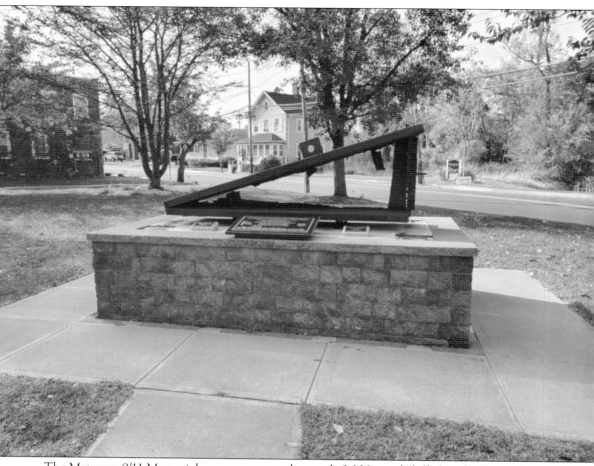

The Matawan 9/11 Memorial commemorates the nearly 3,000 people killed in the September 11, 2001, terror attacks. This memorial honors residents including Thomas A. Damaskinos, Edward P. Felt, Lance Richard Tumulty, Kenneth F. Tietjen, George Patrick McLaughlin Jr., and Virginia M. Jablonski. (Author's collection.)

Middletown's World Trade Center Memorial Gardens honor the community's 37 residents who perished in the September 11, 2001, terror attacks. Middletown lost the second most residents of any municipality behind New York City. The memorial gardens were opened on the second anniversary of 9/11. (Randall Gabrielan.)

County Is Declared A Disaster Area In Wake of Hurricane

SURVEYING THE SCENE of damage in Keansburg caused by Hurricane Donna are state and local officials who made a tour of the stricken Bayshore area yesterday. Assemblyman Alfred N. Beadleston, right, points out some of the damage at the Keansburg pier to, left to right, Mayor Robert S. McTague, Atlantic Highlands, State Sen. Richard R. Stout and Keansburg Mayor James J. Gravany. These officials, plus mayors of neighboring communities, met with Rep. James C. Auchincloss to discuss means of obtaining state and federal aid for victims of Monday's hurricane.

Although Hurricane Donna did not make landfall in New Jersey, the September 1960 storm still delivered intense winds and massive flooding throughout the state. Waterfront infrastructure throughout the Raritan Bayshore region was badly damaged or destroyed by this storm. For some communities, this storm helped to mark the end of their time as popular summer tourist destinations. (*Red Bank Register.*)

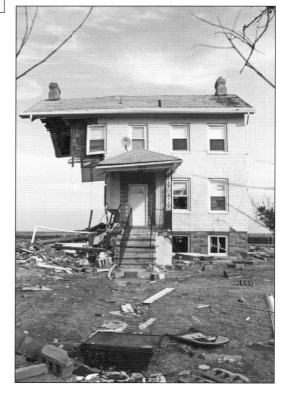

In 2011 and 2012, the Raritan Bayshore region was rocked by Hurricanes Irene and Sandy. Left in the wake of these storms were deaths and billions of dollars of damage throughout the state of New Jersey alone. Both storms left some residents in the Raritan Bayshore region without power and displaced from their homes for days. This photograph is of a home destroyed by Hurricane Sandy in Union Beach. (Blackwaterimages.)

Ten

ENTERTAINMENT AND SPORTS

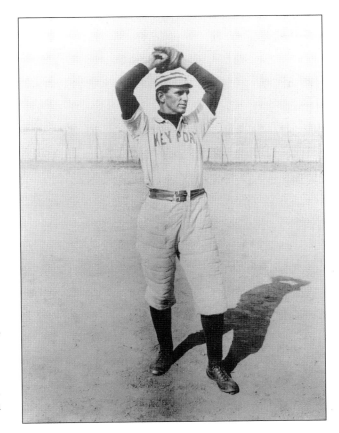

Christy Mathewson was a World Series champion pitcher who played professionally from 1900 to 1916, spending much of his career with Major League Baseball's New York Giants. In September 1904, Mathewson was recruited to pitch for Keyport against a team from rival Matawan. Keyport reportedly won the game by a score of 2-0 behind Mathewson's one-hitter performance and 15 strikeouts. He was inducted into the Baseball Hall of Fame in 1936. (Monmouth County Historical Association.)

Juanita Hall (née Long) was born in Keyport on November 6, 1901. A graduate of Keyport High School, Hall went on to attend the Juilliard School of Music in New York City. Hall played Bloody Mary in the 1949 Broadway show *South Pacific*, a role that led to her becoming the first African American to win a Tony Award for Best Supporting Actress in 1950. Hall died in 1968 and is interred at Midway Green Cemetery in Matawan. (Library of Congress.)

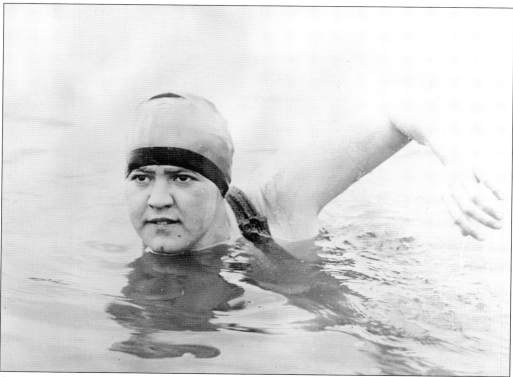

At 21 years old, Gertrude Ederle was the first woman to swim the English Channel in 1926. Gertrude's father taught her how to swim at their summer home in Highlands, and at times she trained in the region for the rest of her career. By age 12, she set her first world record in the 880-yard freestyle, becoming the youngest swimming world record holder. Ederle medaled in three events at the 1924 Paris Summer Olympics. (Author's collection.)

A lifelong resident of Sayreville, Edward Joseph Popowski (pictured, left), known as "Pop" or "Buddy," served as a baseball player and coach in the Boston Red Sox organization from 1937 to 1976. His career took him to the big leagues as a coach from 1967 to 1976. He stayed on as an instructor and coordinator until 2001. Popowski died on December 4, 2001, in Sayreville and is interred at nearby New Calvary Cemetery. (Author's collection.)

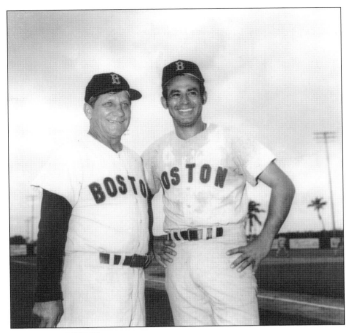

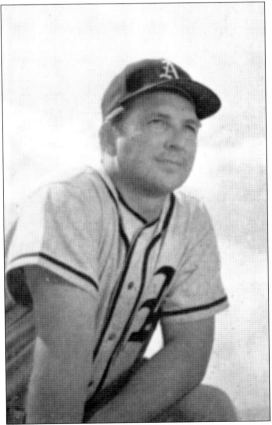

South Amboy's Allie Clark was a seven-season (1947–1953) Major League Baseball veteran who played for the New York Yankees, Cleveland Indians, Philadelphia Athletics, and Chicago White Sox. Following his service during World War II, Clark returned to the baseball diamond, making the 1947 World Series champion Yankees' roster. After baseball, Clark returned home to work full-time as an ironworker. He died in 2012 and is interred at South Amboy's Christ Church Cemetery. (Author's collection.)

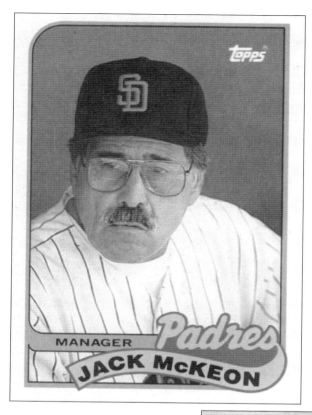

Major League Baseball manager Jack McKeon was born in South Amboy on November 23, 1930. He attended St. Mary's High School in South Amboy, where he excelled at baseball. Between 1973 and 2011, McKeon managed five different teams. At the age of 72, he led the Florida Marlins to a World Series title, defeating the New York Yankees in 2003. McKeon retired from managing with over 1,000 career victories. (Author's collection.)

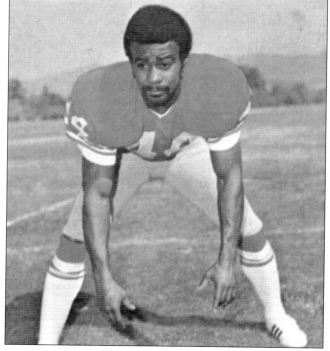

A 1966 graduate of Perth Amboy High School, Bruce Taylor was drafted by Major League Baseball's Baltimore Orioles but declined this opportunity to play football at Boston University. His success in college football led to an eight-year career with the National Football League's San Francisco 49ers. He retired from the NFL in 1977 and was inducted into the College Football Hall of Fame in 1997. (Author's collection.)

Tom Kelly's baseball career began at St. Mary's High School in South Amboy. Major League Baseball's Seattle Pilots drafted Kelly in 1968. In 1975, Kelly played in 49 games with the Minnesota Twins. Following his playing days, Kelly joined the coaching ranks, being named manager of the Twins in 1986. As manager of the Twins, Kelly captured two World Series championships in 1987 and 1991. (Author's collection.)

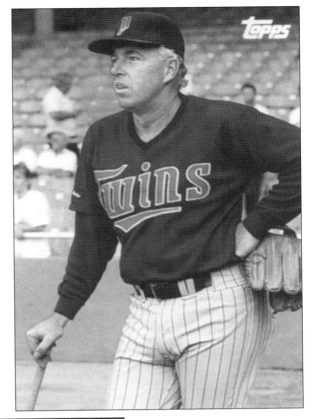

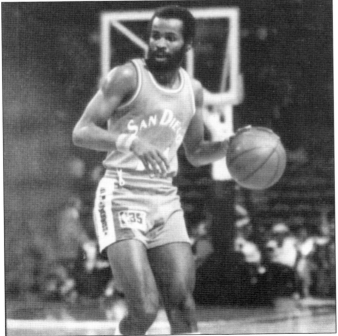

Born on June 9, 1952, in Perth Amboy, Brian Taylor led the Perth Amboy High School Panthers to a state championship in 1968. His performance at Princeton University led to his selection in the second round of the 1972 National Basketball Association draft. Taylor played for the New York Nets, Kansas City Kings, Denver Nuggets, and San Diego Clippers between 1972 and 1982. In 2021, Perth Amboy dedicated the basketball courts in Washington Park to Taylor. (Author's collection.)

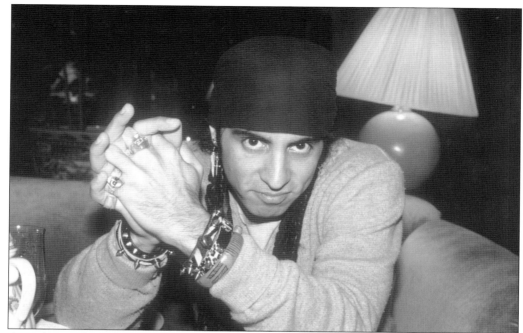

A graduate of Middletown High School, Steven Van Zandt became interested in music at a young age. In the 1970s, "Little Steven" joined the iconic New Jersey rock and roll group Bruce Springsteen's E Street Band. A veteran of numerous tours with the band, Van Zandt plays the guitar and mandolin. Van Zandt also appeared in the popular HBO crime drama *The Sopranos*. (Author's collection.)

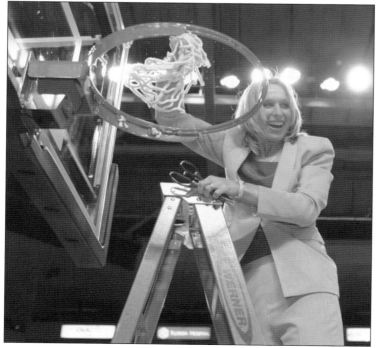

A standout basketball player at Sayreville War Memorial High School, Rhonda Rompola went on to capture two college basketball championships with Old Dominion University (1979 and 1980). After college, Rompola entered the coaching ranks, first as assistant head coach with Southern Methodist University (SMU) and later as a head coach from 1991 to 2016. Rompola received a number of honors, including 1999 Western Athletic Conference Coach of the Year. (SMU Athletics.)

Born on March 2, 1962, in Perth Amboy, John Francis Bongiovi Jr., better known as Jon Bon Jovi, is a musician, actor, and philanthropist who found fame as the front man for the rock band Bon Jovi. A 1980 graduate of Sayreville War Memorial High School, Bon Jovi started playing music at the age of 13. In 1984, his band released its debut self-titled album, *Bon Jovi*. (Author's collection.)

Club Bene (or Bené) opened in 1968 on Route 35 in the Morgan section of Sayreville. The club's original owner, Joseph Beninato, opened Club Bene in a former 14-lane bowling alley with the goal of hosting dinner theater shows. The club, later renamed Club Krome, hosted numerous musicians and entertainers, including Bon Jovi, George Carlin, Gilbert Gottfried, Howard Stern, Meatloaf, and the Ramones. Club Krome was demolished in 2014. (Author's collection.)

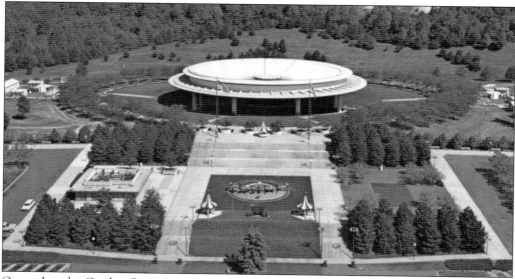

Opened as the Garden State Arts Center in 1968, PNC Bank Arts Center is an amphitheater concert and events center in Holmdel. The venue, which holds approximately 17,500 people, is a premier concert venue for various genres of music. Notable performances at the Arts Center over the years include James Taylor, Frank Sinatra, Bruce Springsteen, the Spice Girls, Sting, Black Sabbath, Phish, and Kenny Chesney. (Author's collection.)

Considered one of Matawan Regional High School's greatest football players, Jim Jeffcoat went on to become one of Arizona State University's greatest defensive linemen. A first-round pick in the 1983 National Football League draft, Jeffcoat won two Super Bowl championships with the Dallas Cowboys before signing with the Buffalo Bills in 1995. Following his retirement in 1997, Jeffcoat has served as a coach for college and professional football teams. (Sun Devil Athletics.)

A standout football player at Matawan Regional High School and Rutgers University, Cliffwood's Jay Bellamy was signed as an undrafted free agent by the National Football League's Seattle Seahawks in 1994. Bellamy played 14 seasons as a safety for the Seattle Seahawks and New Orleans Saints. Following his retirement from professional football in 2007, he returned to New Jersey, where he coaches high school football. (Author's collection.)

Woody Allen's *The Purple Rose of Cairo* was released on March 1, 1985, and stars Mia Farrow (pictured) and Jeff Daniels. The film, set during the Great Depression, tells the story of a waitress (Farrow) who escapes her problems by watching movies, eventually leading to her launch into a comedic and dramatic fantasy world. Parts of the film were shot at the Raritan Diner in South Amboy. (Author's collection.)

The alternative rock band Tonic's Emerson Hart grew up in Atlantic Highlands. Hart, a graduate of nearby Red Bank Catholic High School, formed Tonic with bandmate Jeff Russo in 1993. The band, founded in Los Angeles, released its debut album, *Lemon Parade*, in 1996. Hart and his bandmates are also active supporters of the USO, having performed for the troops on military bases in the Middle East and the Balkans. (Author's collection.)

John Molnar discovered boxing at the age of 15 when he started training at the Middletown Police Athletic League (PAL). Molnar fought professionally from 1997 to 2005, and despite never obtaining a title shot, he gained notoriety boxing on the undercards of notable fighters such as Lennox Lewis, Arturo Gatti, and Pernell Whitaker. Molnar tragically passed away on May 31, 2022, at the age of 47. (New Jersey Boxing Hall of Fame.)

Imamu Mayfield was born in Perth Amboy on April 19, 1972. Mayfield was discovered by 1976 Olympic Gold Medalist Howard Davis Jr. while training at the Perth Amboy PAL. Between 1994 and 2017, Mayfield compiled a record of 26 wins, 10 losses, and 3 draws, holding the International Boxing Federation world cruiserweight title between 1997 and 1998. He is co-owner of Freehold Boxing and Fitness. (Author's collection.)

Clerks (1994) is a black-and-white comedy film written and directed by Highlands' Kevin Smith. The cult classic, set in Leonardo, tells the story of convenience store employee Dante Hicks (Old Bridge Township's Brian O'Halloran). Called into work on his day off, he encounters a number of local characters, including close friend Randal Graves (Atlantic Highlands' Jeff Anderson) and Jay and Silent Bob (Highlands' Jason Mewes and Smith). (Author's collection.)

In the 2000 coming-of-age film *Coyote Ugly*, Violet Sanford (Piper Perabo) leaves her hometown of South Amboy to pursue a career as a singer and songwriter in New York City. The strapped-for-cash Sanford, fearing failure, auditions for and is hired onto the all-female staff of a popular bar called Coyote Ugly, where she participates in a number of dance routines on the bar top. (Author's collection.)

Before playing five seasons in the National Football League, Cliffwood's Charlie Rogers was a standout football star at Matawan Regional High School and Georgia Tech. During his 1999 rookie season with the Seattle Seahawks, Rogers led the NFL in average punt return yardage. Rogers retired from the NFL following his 2003 season with the Miami Dolphins. He went on to coach numerous levels of football in the Matawan area. (Author's collection.)

A 2003 graduate of Matawan Regional High School, Erison Hurtault went on to have a prestigious running career at Columbia University. During the Beijing (2008) and London (2012) Olympic Games, Hurtault (pictured with flag) represented his parents' homeland of Dominica in the 400-meter dash. He served as the head coach of New York University's men's and women's cross country and track and field teams between 2016 and 2021. (Author's collection.)

A native of Middletown, James van Riemsdyk is one of the highest National Hockey League draft picks from the state of New Jersey. Van Riemsdyk's hockey career began as a youngster at the Old Bridge Ice Arena. A former player at Christian Brothers Academy in Lincroft, van Riemsdyk's career has taken him to Philadelphia and Toronto. His younger brother Trevor won the Stanley Cup in 2015 with the Chicago Blackhawks. (Author's collection.)

Connor Clifton is a defenseman in the National Hockey League. A native of Matawan, Clifton played ice hockey with his older brother Tim at Christian Brothers Academy in Lincroft and Quinnipiac University in Connecticut. Clifton was part of the 2018–2019 Eastern Conference champion Boston Bruins team that fell to the St. Louis Blues in the Stanley Cup Finals. (Quinnipiac Athletics.)

Monica Aksamit, a 2008 graduate of Matawan Regional High School, won the bronze medal in the women's saber team event at the 2016 Summer Olympic Games in Rio de Janeiro. Before medaling in the Olympic Games, Aksamit was a three-time All-American fencer at Pennsylvania State University. She also served as a fencing coach at St. John Vianney High School in Holmdel from 2015 to 2017. (Author's collection.)

MONICA AKSAMIT
FENCING

Old Bridge Township's Laurie Hernandez represented the United States at the 2016 Summer Olympics in Rio de Janeiro, winning a gold medal in the women's artistic team all-around competition and silver in the women's balance beam competition. Following her medal-winning Olympic performance, Hernandez appeared on a number of television shows, including *Dancing with the Stars*. (Author's collection.)

DISCOVER THOUSANDS OF LOCAL HISTORY BOOKS
FEATURING MILLIONS OF VINTAGE IMAGES

Arcadia Publishing, the leading local history publisher in the United States, is committed to making history accessible and meaningful through publishing books that celebrate and preserve the heritage of America's people and places.

Find more books like this at
www.arcadiapublishing.com

Search for your hometown history, your old stomping grounds, and even your favorite sports team.

Consistent with our mission to preserve history on a local level, this book was printed in South Carolina on American-made paper and manufactured entirely in the United States. Products carrying the accredited Forest Stewardship Council (FSC) label are printed on 100 percent FSC-certified paper.